IMAGES
of America

WEST HARTFORD

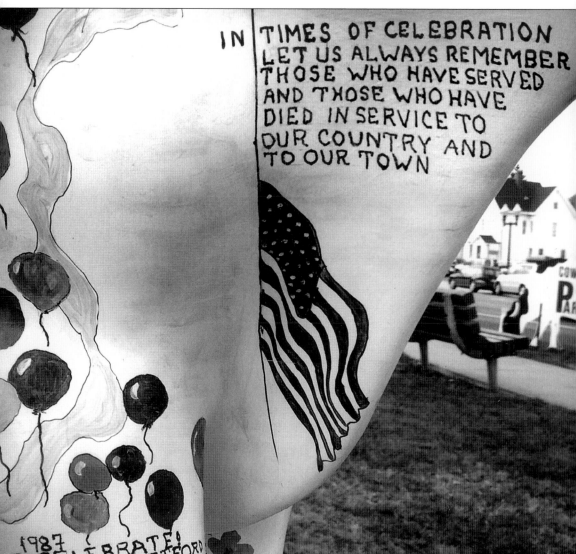

The year 2004 marks the 150th anniversary of the formal separation of West Hartford from the city of Hartford. The incorporation of the town was signed by Gov. Charles H. Pond on May 3, 1854. The 150th Celebration Cow of the 2003 Cow Parade in West Hartford Center included the following inscription: "In times of celebration let us always remember those who have served and those who have died in service to our country and to our town." (WHHS.)

IMAGES
of America

WEST HARTFORD

Wilson H. Faude

ARCADIA
PUBLISHING

Published by Arcadia Publishing
Charleston SC, Chicago IL, Portsmouth NH, San Francisco CA

Printed in the United States of America

Library of Congress Catalog Card Number: 2003112947

For all general information contact Arcadia Publishing at:
Telephone 843-853-2070
Fax 843-853-0044
E-mail sales@arcadiapublishing.com
For customer service and orders:
Toll-Free 1-888-313-2665

Visit us on the Internet at www.arcadiapublishing.com

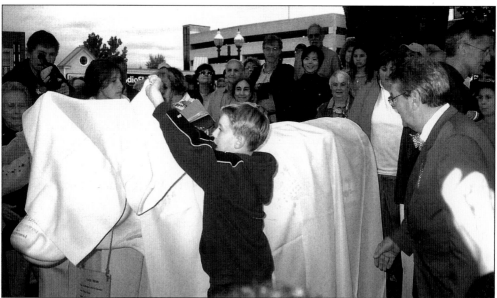

On September 3, 2003, the cows of Cow Parade in West Hartford were presented to the public.
Fittingly, the very first cow unveiled was the "Cow in Celebration," created in honor of the
150th anniversary of West Hartford's incorporation. Doing the honors are Nan Glass (far left)
of the celebration committee, her granddaughter Jessica Glass, and Paul Faude, son of the cow's
artist. (WHHS.)

CONTENTS

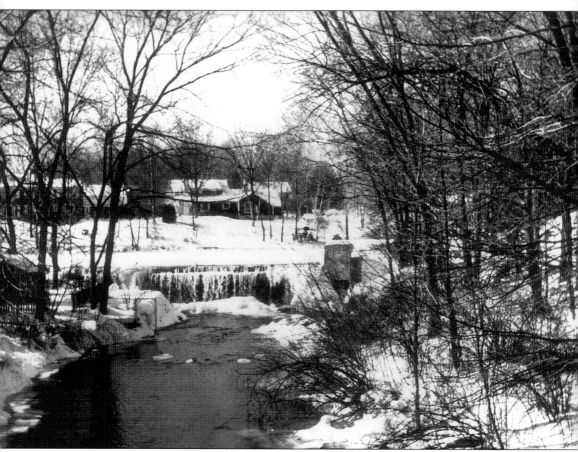

The modern settlement of the West-Division (West Hartford) began in 1679, when Stephen Hosmer built a house and sawmill on North Main Street between Wyndwood Road and Brookside Boulevard. Later, Captain Goodman and others built mills there. The house at 175 North Main used a former gristmill stone as its front doorstep. The millpond is pictured from the North Main Street Bridge. (WHHS, 0261.)

This book is for all who love West Hartford.
This book is for Nan Glass, a tireless public servant and a most gracious lady.
This book is for my wife, Janet, and our two great children, Sarah and Paul.
We consider ourselves fortunate to be living in this most special place.

INTRODUCTION

West Hartford is not overly large, just 22.2 square miles. Its population in 2000 was 61,046. It has grown from a very rural pastoral community through the late 1930s (with a population of 24,941) to an all-time high in 1970 (with 68,031). This rapid growth meant sudden changes to the town, the need for more services, better roads, more schools, shops, and regulations. Acres of pastureland and centuries-old homes were lost to the urban sprawl. After 1970, there was a sudden shrinkage. In 1980, there were 61,301 people in the town. The reversal closed schools and shops and reduced services as the tax base shrank. This example illustrates that towns like West Hartford are fragile and evolving places. Bigger is not always better.

This pictorial history is a companion piece to the three worthy histories that preceded it: William H. Hall's *West Hartford*, published in 1930; Nelson R. Burr's *From Colonial Parish to Modern Suburb*, published in 1976; and Miriam Butterworth, Ellsworth Grant, and Richard Woodworth's *Celebrate! West Hartford*, published in 2001.

When assembling the views, many of them hitherto unpublished, I was struck at how fleeting is the history of West Hartford. Everyone assumes that someone else is keeping the history. Although the West Hartford Historical Society, the town library, and the town hall have done valiant jobs on modest means, much has been lost. For example, when the West Hartford News was sold to the Bristol Press, the financials and the bound volumes were saved, but all of the photographs went to the dump. So, if you have pictures of West Hartford, please donate them to the West Hartford Historical Society or another permanent repository so the story will be preserved. In many cases, as you will see here, a picture of your great-aunt or a car crash may also preserve the landscape or buildings that would otherwise be lost.

Many people generously gave of their time, pictures, and knowledge during the creation of this book. First and foremost were Sheila B. Daley, archivist of the Noah Webster House and the West Hartford Historical Society (WHHS), and the former director, Vivian Zoe. Richard Mahoney of RLM and Pat Sinatro of the Sinatro Agency were invaluable counselors to the book. Ron Van Winkle, Norma Cronin, and Renee McCue of the Town of West Hartford (TOWH) unearthed unpublished photographs and verified dates and details. The following people and organizations offered enthusiastic support with their time and photographs: James Strillacci (chief of police) and Robert McCue (assistant chief) of the West Hartford Police Department (WHPD); William Austin (chief), Gerald Leblanc (captain) of the West Hartford Fire Department (WHFD); Tom Reddin of West Hartford Professional Family Hair Care; Jennifer Philip of Renbrook School; St. John's Episcopal Church; Art Kiely; the S.P. Dunn family; Kevin Keenan of the Taubman Company; Yvonne Goldstein; Marjorie Rafal; and Stephen Dunn. Lastly, I wish to thank Kathleen McKula, news librarian at the Hartford Courant, who patiently helped me comb the Courant archives. I extend my thanks to her, to Cheryl Magazine of permissions, and to Courant publisher Jack Davis, who graciously allowed use of the photographs.

Let the photographs and the memories begin.

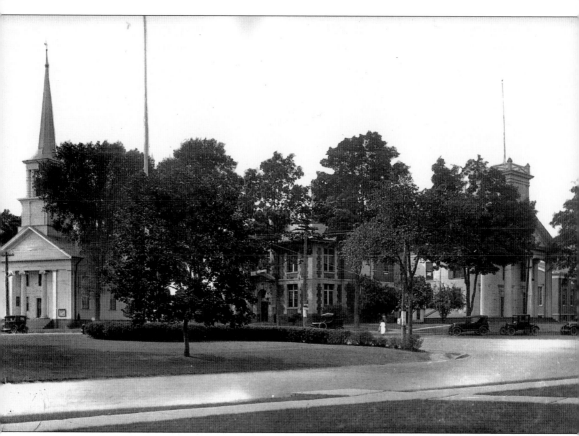

West Hartford Center, at the corner of Farmington Avenue and North Main Street, is shown as it looked in the 1920s. On the left is the Baptist church (1859), which stood on the site later occupied by Maxwell Drugs (page 11) and People's Bank. To the right of it are the town office building (1902); the Congregational church (1834), which was used as the town hall from 1882 to 1936; and the Noah Webster Memorial Library (1917). The Congregational church was torn down in 1957 to create a small park. (WHHS, 0235C.)

One

WEST HARTFORD CENTER

This rare view of the center looks west on Farmington Avenue. Note the houses and barns and the lone horse and sleigh, all vestiges of a rural agricultural town. The year is c. 1890. Eight years earlier, the first high school opened. In another eight years, West Hartford's first major market, Burnham's, opened. The columned house on the right is where the Central Theater was built in 1924. (Richard Mahoney.)

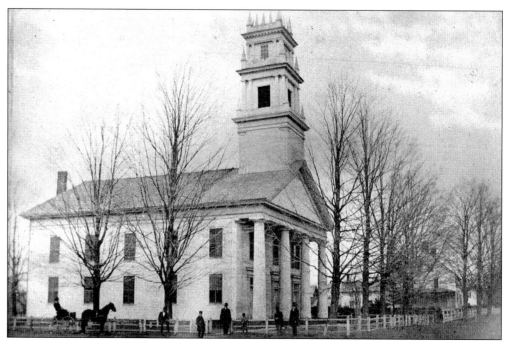

The Congregational church, on the corner of Farmington Avenue and North Main Street, is pictured *c.* 1860. Note the simple wooden fence and the layered steeple. The Brace homestead is to the right. The steeple's extra layers were removed when the building became the town hall, as is seen below. (WHHS, 0207B.)

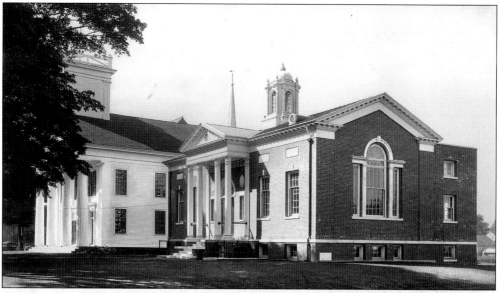

On the corner of North Main Street and Brace Road stood the Congregational church (left) and the Noah Webster Memorial Library. The library began in the church in 1897. When it outgrew its space, the Daughters of the American Revolution raised $40,000 to build this new library. It was dedicated on February 27, 1917. In 1938, the library moved to 20 South Main Street, and the building was leased to the YMCA. In 1980, Terry Wilson rescued and restored the building as offices for the J. Watson Beach real-estate office. (WHHS, 0230K.)

Between the Baptist church and the Congregational church stood the town office building. Built in 1902 to accommodate the growing town government, it was overcrowded by 1933. In 1936, after heated debate whether to accept federal funds, it was voted to use Work Projects Administration money to build a new town hall and offices on South Main Street. The new building was completed in nine months, and the town office building was razed. (WHHS, 0230C.)

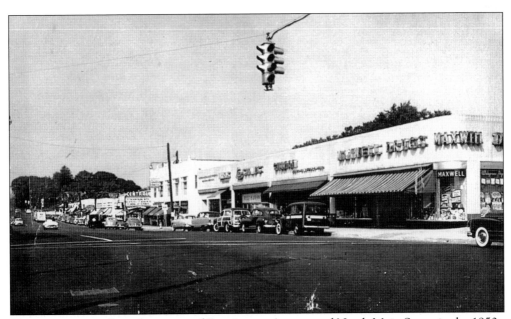

The center is seen from the corner of Farmington Avenue and North Main Street in the 1950s. Where the Baptist church and the town office building once stood is the modern Maxwell Drugs, which opened in 1946. (Richard Mahoney.)

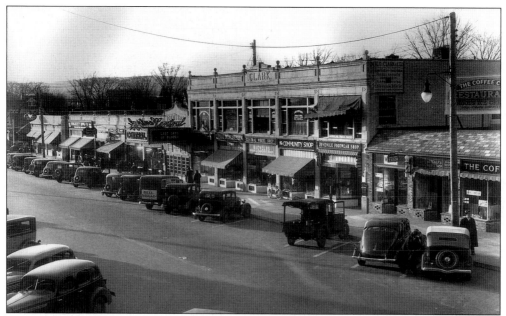

The north side of West Hartford Center on Farmington Avenue is pictured in the fall of 1935. In 1930, the Dougherty drugstore opened in the Central Theater block. Next door, in the 1920s Clark building, are the Central Delicatessen and the Central Wheel Shop. Their names reflected their location next to the theater. To the right are a tailor shop, a barbershop, and The Coffee Cup Restaurant. (WHHS, Kiely.)

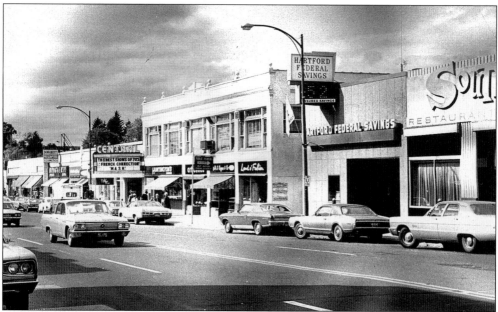

The north side of the center is shown in November 1972. The Dougherty drugstore and the Central Theater are still there, joined by Huntington's Book Store, Artichoke, B.L. Eyges, and Land o' Fashion. The Coffee Cup block has been razed for an access alley to the parking lot, and a building has been constructed for Hartford Federal Savings and the South Seas restaurant. (Copyright the Hartford Courant, reprinted with permission.)

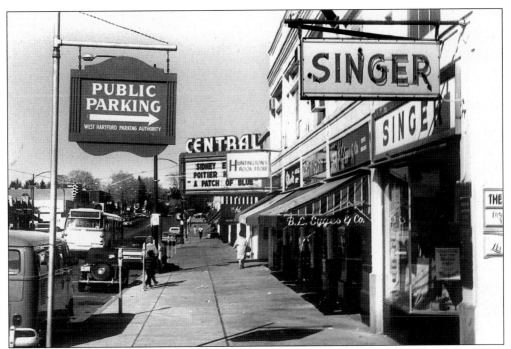

The Clark Block is pictured in this 1966 photograph. The Central is showing *A Patch of Blue*, starring Sidney Portier. In 1960, Trumbull Huntington purchased Witkowers Bookstore and renamed it Huntington's Book Store. Isaac Epstein was the much beloved manager of the store in West Hartford and later in Hartford. (TOWH.)

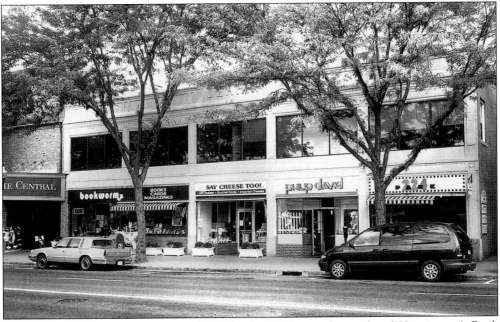

In this present-day view of the Clark Block, the Bookworm has replaced Huntington's Book Store. Say Cheese Too, Philip David jewelers, and the 224 Park ladies' clothing store complete the block. (WHHS.)

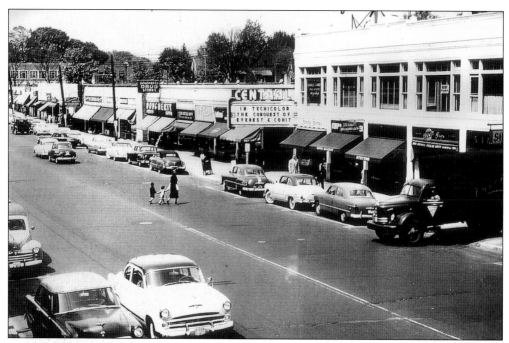

In 1953, the Central Theater was showing Edmund Hillary's *Conquest of Everest*. The Fanny Farmer store is to the right of the theater, followed by the Central Delicatessen and Stevens jewelry store. (WHHS, 0128B.)

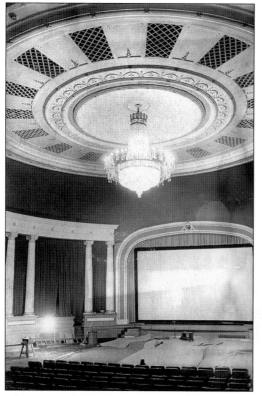

Before the creation of multiscreened cinemas, the Central Theater was the place to go. The interior was splendid with its white-and-gold columns and enormous crystal chandelier. On June 23, 1977, the Central closed as a movie house. In January 1979 (as shown here), it was converted into a disco-dancing palace. The disco failed, and in 1985, Leonard Udolf purchased the building. (Copyright the Hartford Courant, reprinted with permission; photograph by John Long.)

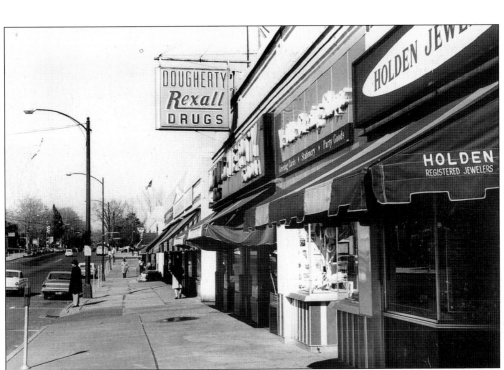

In 1966, the Central Theater block included the Dougherty drugstore, Ye Olde Greeting Shoppe, and Holden Jewelers. Holden closed in 2003 after many years in business. (TOWH.)

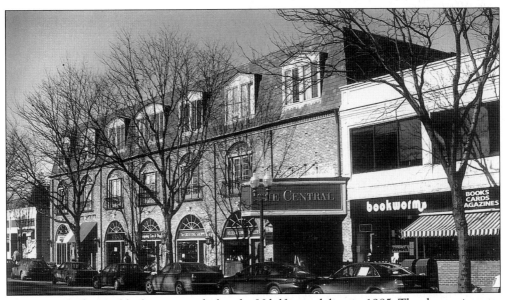

The Central Theater block is pictured after the Udolf remodeling in 1985. The theater is gone, except for the naming marquee. Two floors for business have been added, and it now has a checkered brick facade. (WHHS, 0639A.)

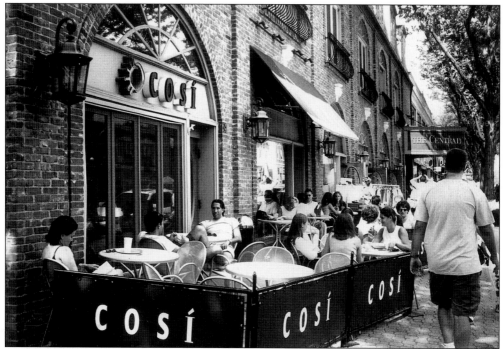

The Dougherty drugstore space in 2003 was the Cosi cafe. Outdoor dining began in 1995. Because of public support, the town council authorized full outdoor service in 1996. (WHHS.)

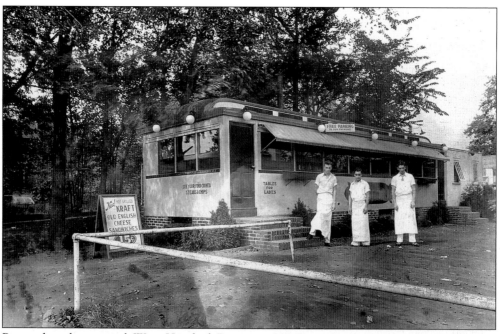

Pictured is the original West Hartford Diner, at 980 Farmington Avenue. Signs advertise "Tables for Ladies" and "New Kraft Old English Cheese Sandwiches." (Tom Reddin, West Hartford Professional Family Hair Care.)

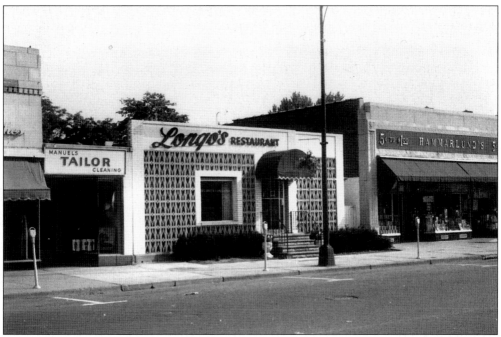

The West Hartford Diner has been transformed and remodeled many times, but beneath the facades, the diner pictured on the opposite page survives. In 1966, it was Longo's Restaurant. Later it was Edelweiss. The Hammerlund's dime store (right) later became Ann Taylor and is now CVS. (TOWH.)

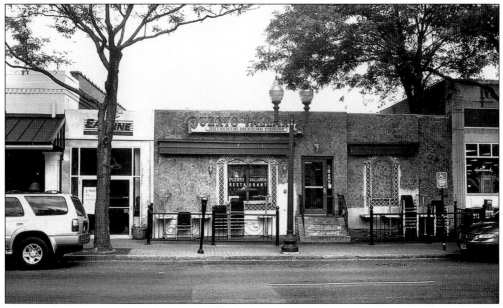

Here is the West Hartford Diner as it looked in 2003 as Puerto Vallarta. To the right, the alleyway has been filled in; every space is important. To the far right is the CVS. (TOWH.)

17

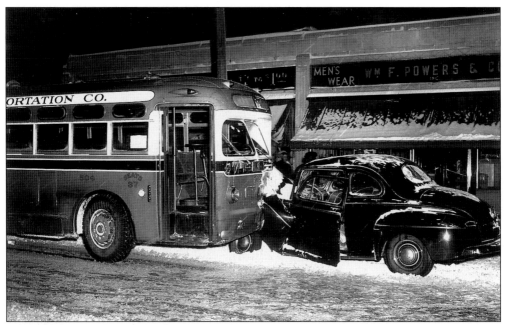

It could ruin your day when a bus loses its breaks, misses the light at the corner of Farmington and LaSalle, and takes out your car. The importance of the photograph is not the wreck, but the documentation of Hammerlund's and the William F. Powers & Company men's clothing store, where CVS is today. This is the only known picture to date of Powers, for years a mainstay in the center along with its Diana Lee Shop for Women. (WHPD, 12.)

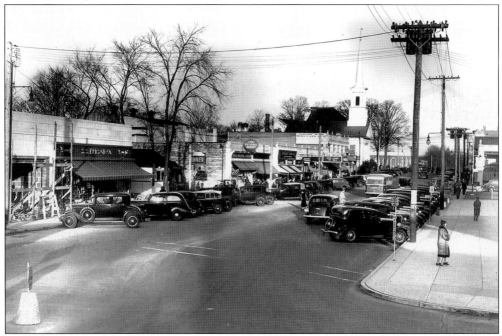

This is the north side of the center in the 1930s. The Baptist church is on the right. The First National market is in the middle next to the West Hartford Diner, and S.S. Kresge is in the building that now is Pfau's Hardware. (WHHS, Kiely.)

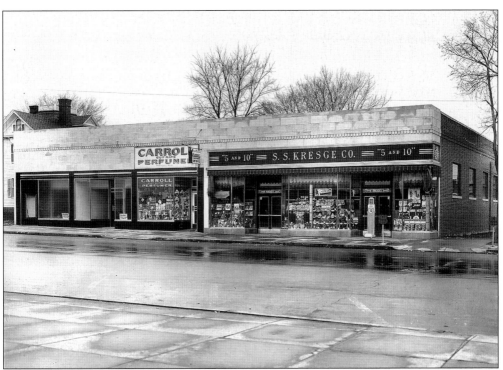

In the 1930s, S.S. Kresge and Carrol Perfume were tenants in the new block west of the diner. In 2003, it was home to Comina, Pfau's Hardware, Ritz Camera, and Relax the Back. (WHHS, 0287.)

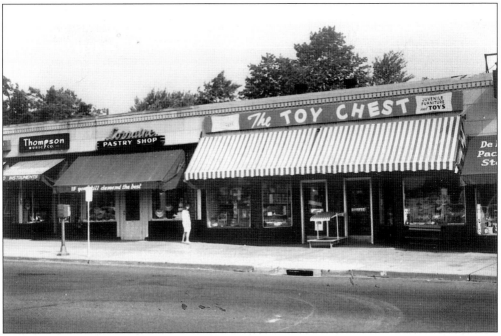

In 1966, the block had the DeLuxe Package Store, the Toy Chest, the Lorraine Pastry Shop, and Thompson Music Company. The pastry shop was known for its fabulous napoleons and other wonderful French and Viennese creations. (TOWH.)

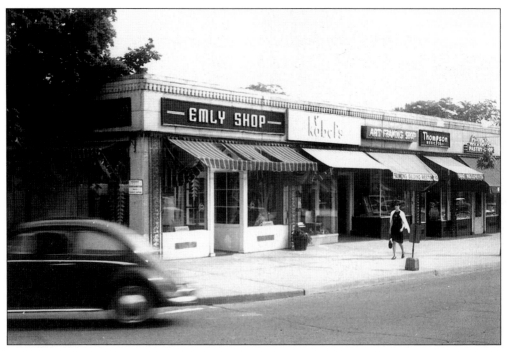

In 1966, west of the Lorraine Pastry Shop was the Art Framing Shop, Kabel's (leather goods), and the EMLY Shop (ladies' dresses). In 2003, Spiritus, the Elbow Room, Japanalia, Art Framing, and Chico's were there. (TOWH.)

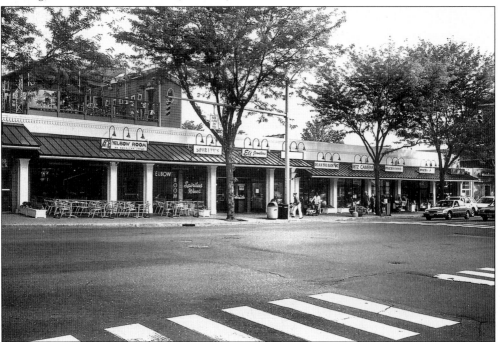

In 2003, the block was remodeled but thriving. In this view, Pfau's Hardware is on the right, followed by Ritz Camera, Peter B's Coffee, Eli Jewelers, Spiritus (wine and liquor), and the Elbow Room, a trendy popular restaurant that served patrons on the roof. (WHHS.)

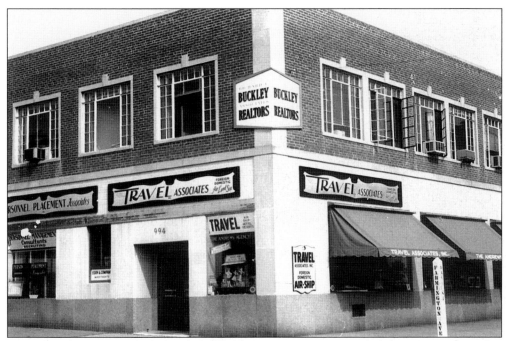

Located at the corner of Dale Road, the building at 994 Farmington Avenue was constructed in 1941. This photograph was taken in 1966. In 2003, the building looked the same, except that Liberty Travel had replaced Travel Associates. (TOWH.)

The south side of Farmington Avenue is shown as it looked on the Fourth of July in 1953. This is a rare photograph, for in the middle one has a view of the Studebaker car dealership and Mobil gas station, followed by Sage-Allen, Doran's Florist, Rexall Drug, and West Hartford Furriers. Sage-Allen opened the store in 1930 and, in 1962, took over the building and added the second floor. (Copyright the Hartford Courant, reprinted with permission.)

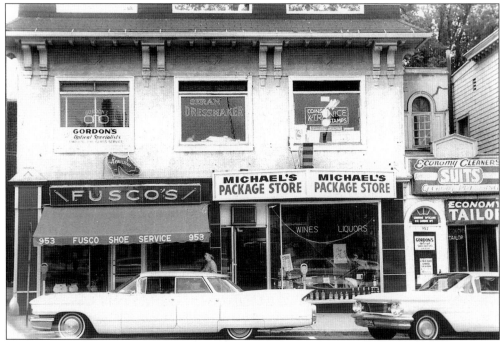

In 1966, the building at 953–957 Farmington Avenue housed Fusco's, Michael's Package Store, and Economy Tailor, with Gordon's Optical, a dressmaker, and a coin and stamp store on the second floor. The building was constructed in 1916. (TOWH.)

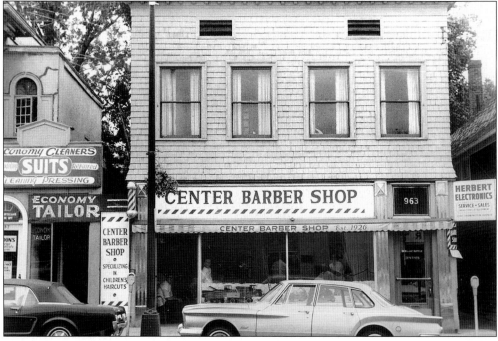

At 963 Farmington Avenue was the Center Barber Shop, with Herbert Electronics in the alley. Every space in the center was filled with large and small stores to meet a customer's needs. In 2003, Daswani Clothing purchased the building. (TOWH.)

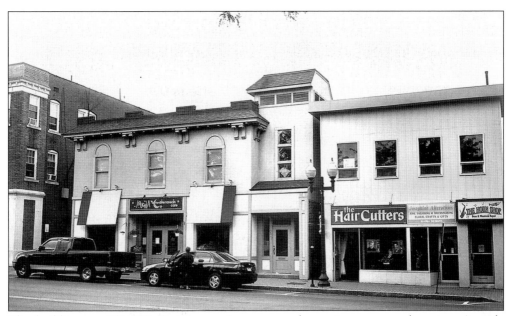

The buildings at 953–963 Farmington Avenue are shown in a present-day view. Arugula Restaurant, a Mediterranean cafe, occupies the former Fusco's and Michael's space, and the exteriors of the buildings have been remodeled. (WHHS.)

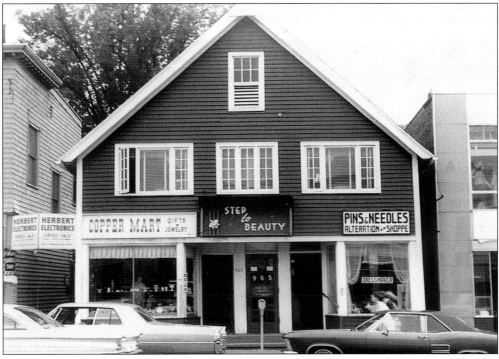

At 965 Farmington Avenue were the Copper Mart, Step to Beauty, and Pins & Needles (an alteration shop). This building, constructed in 1968, and the one to the right were remodeled in 1988. (TOWH.)

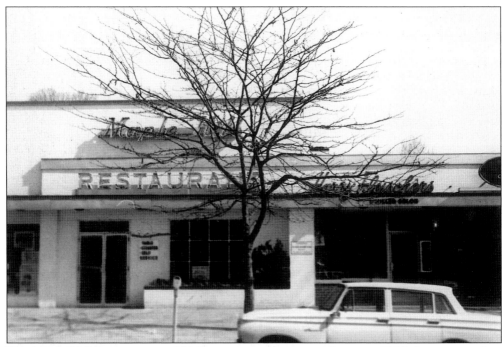

The Maple Hill Restaurant, at 971 Farmington Avenue, is shown in 1966. It was started in Hartford in 1942 by David LeFavour, who opened a second Maple Hill in West Hartford Center in the mid-1950s. Next to the restaurant were Zacher's Photography (out of frame to the left) and Harry Fleischers (right). (TOWH.)

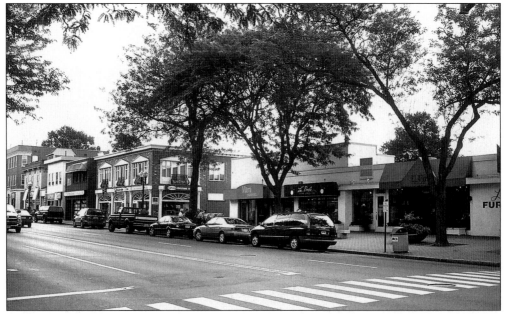

In this present-day view of the 967–971 block, note that a brick facade has joined the two buildings. Mimi Maternity, La Perla Fine Jewelers, Lyn Evans, and E.L. Wilde now occupy the former Maple Hill building. The Back Porch restaurant is open in the back of the Maple Hill. (WHHS.)

At 981 Farmington Avenue was Hilliard's Kitch-in-Vue candy store, where sumptuous candies were made on the premises. During the West Hartford Days in 1954, Douglas P. Hilliard set a goal of selling one ton of fudge. In the two-day sale, he sold over 3,000 pounds of candy and over a ton of fudge. (Copyright the Hartford Courant, reprinted with permission.)

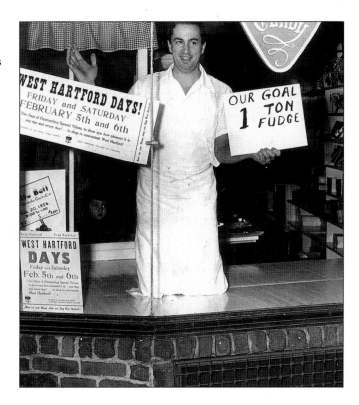

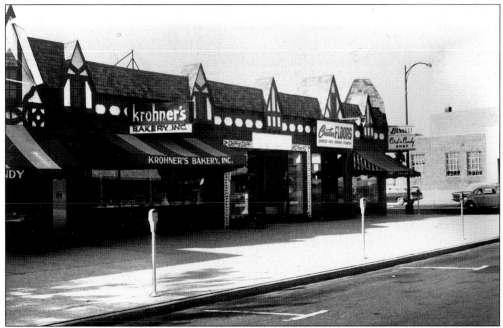

Hilliard's is on the left, followed by Krohner's Bakery, the Lily Salit dress shop, Custom Floors, and Bennett's Card and Candy Shop. Plimpton's opened in the Bennett's space and later moved across LaSalle Road. No birthday was complete without a Krohner's cake with its center layer of sweet jelly. (TOWH.)

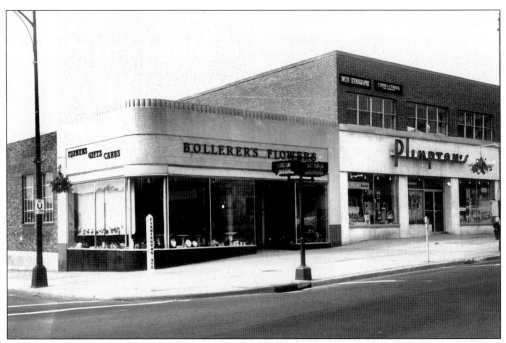

The post office was at the corner of Farmington Avenue and LaSalle Road. In 1932, it moved out and Bollerer's Flowers moved in. The all-glass front filled with orchids and exotic plants was visually warming during winter snowstorms. (TOWH.)

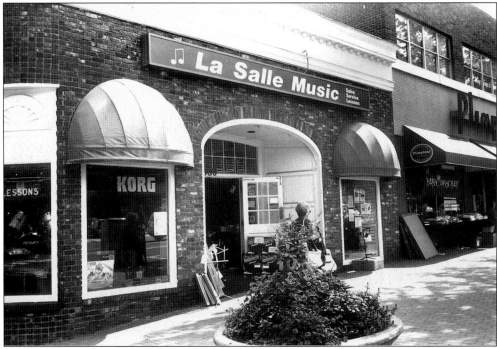

Bollerer's moved to Park Road in 1971, and the facade was bricked up for the new trademark look of the Casual Corner clothing store. In 2003, the store was the home of LaSalle Music. Next door is Plimpton's Stationery, which has greatly expanded through the years. (WHHS.)

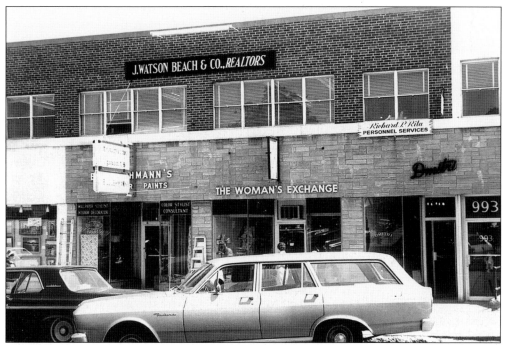

In this 1966 photograph is Bill Lehmann's paint and wallpaper store, located next to Plimpton's. Also shown are the Woman's Exchange and the Dimitri hair salon. The Woman's Exchange moved from Hartford and opened in West Hartford Center on April 8, 1949. It specializes in high-quality handmade items. (TOWH.)

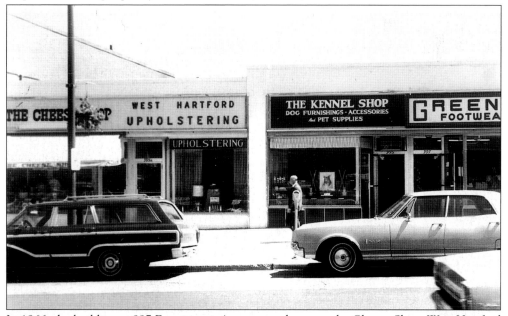

In 1966, the building at 997 Farmington Avenue was home to the Cheese Shop, West Hartford Upholstering, the Kennel Shop, and Greene's Footwear. Anything you needed was to be found in the center. Today, Frame Dimensions, Honore Gallery, the Clay Pen, and G.W. Crane are in these stores. (TOWH.)

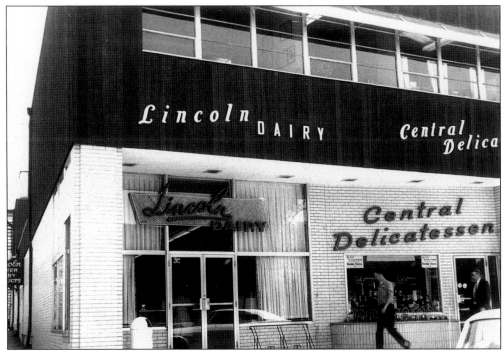

In 1954, Sam Lavery, Mr. Godickson of Lincoln Dairy, and others built the stores at 1003 Farmington. When it opened Lincoln Dairy, the Central Delicatessen, S.K. Lavery Appliance, and Doran's Florist were there. In 2003, the block was home to Harry's Pizza, Fleet Feet, S.K. Lavery, Its Beauty Time, and Labrazel Home. (TOWH.)

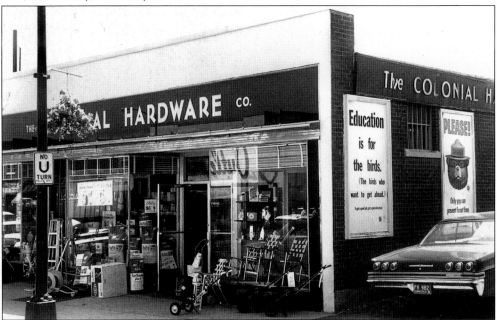

LaSalle Road in the center was curiously named after Robert Cavelier LaSalle, the French explorer. At 21 LaSalle Road was Colonial Hardware, which in 2003 was the home of Starbucks. (TOWH.)

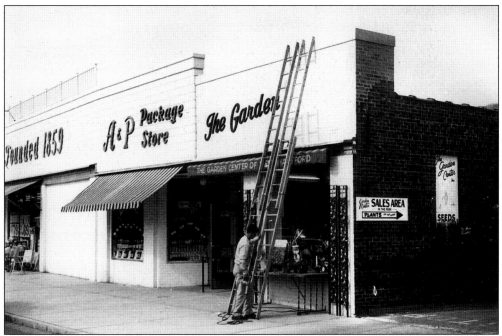

At the end of LaSalle Road (where the Webster Bank has a branch) were the A&P and its liquor store, seen here in 1966. Next door and behind the building was the Garden Center, which Mr. McIntyre ran with congenial grace. He could find a solution to almost any gardening problem. (TOWH.)

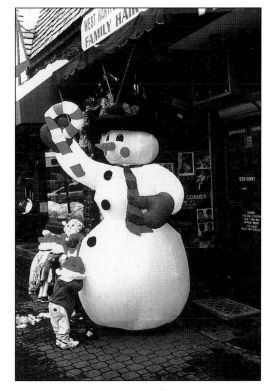

On July 2, 1958, Tom Reddin opened West Hartford Professional Family Hair Care at 18 LaSalle Road. One of the traditions in the center is Reddin's holiday sidewalk displays, including this larger-than-life snowman with one of his little people at its base. (Tom Reddin, West Hartford Professional Family Hair Care.)

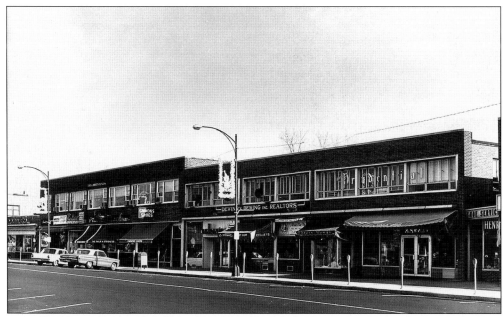

Pasquale Sinatro developed the east side of LaSalle Road in the 1940s. Shown here is the Sinatro Block (left) with Wood's Sports Shop, Philip Stevens (a jeweler), and Simmons Shoes. The S.P. Dunn store is on the far left. The building to the right was built in the early 1950s. (Sinatro.)

Edmund P. Dunn opened S.P. Dunn's on LaSalle Road in 1949. He named the textile store after his father, Stephen Paul Dunn. In time, the store moved to 48 LaSalle, where Lux Bond and Green is today. The store had everything you would want in fabrics and threads. It closed in February 1990. (The Dunn family.)

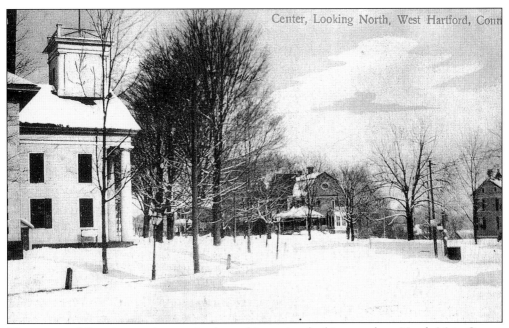

The corner of Farmington Avenue is pictured in a view looking north to North Main Street. The Congregational church is on the left. Also visible is the house where the Fleet Bank building stands today. Judging from the style of the houses and the fact that the church has lost its top steeple layers, the photograph was taken *c.* 1900. (Richard Mahoney.)

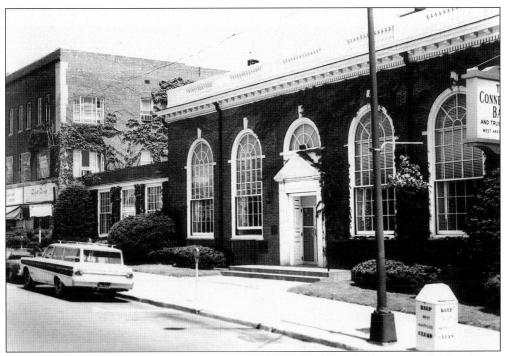

The West Hartford Trust Company, West Hartford's first bank, was built at 4 North Main Street in 1926. The building has also housed CBT, Bank of New England, and Fleet. (TOWH.)

31

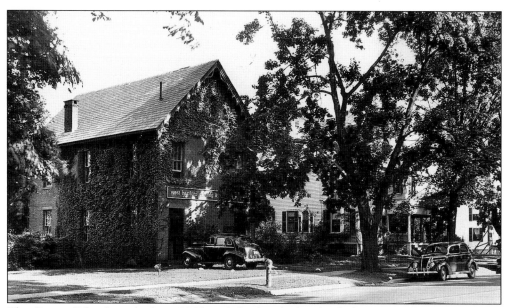

The Center School was built in 1865, and the first high school classes were held here on the second floor from 1872 and 1896. The building later housed a commercial establishment. It was torn down in April 1968 to provide a parking entrance for the building to the right, at 10 North Main Street. (WHHS, 0287B.)

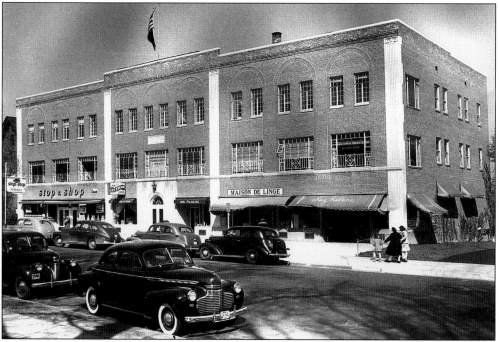

The Professional Building was built between 1942 and 1945. The staggered construction was due to a shortage of materials during the war. On the left is the Stop and Shop market, followed by the ice-cream store (today Sally and Bob's), the Pascos (fine crafts and gifts), and Maison De Linge. A penthouse for the owner was later added to the roof and is now the offices of RLM Company. (WHHS, Kiely.)

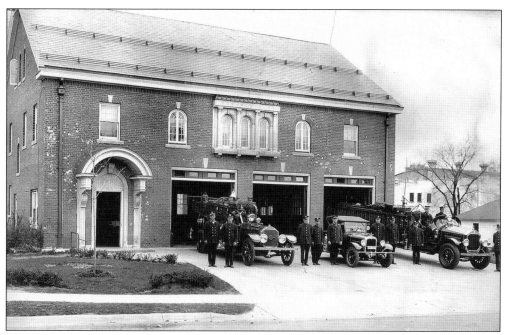

The Center Fire District firehouse was erected in 1925 on Brace Road. It served West Hartford Center until 1991, when a new firehouse was built across the street and the old firehouse became the home of Pompanoosuc Mills. (WHHS, 0281C.)

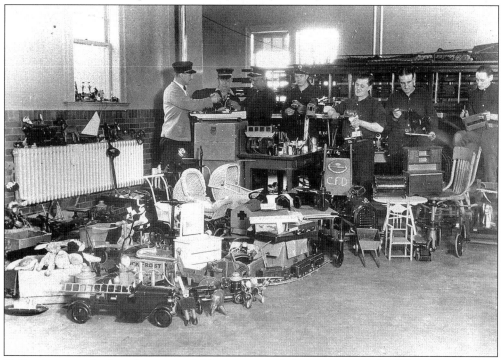

Collecting toys for less fortunate children is one of the many ways the West Hartford Fire Department positively supports the people of West Hartford. They give many unpublicized hours touring scouts, demonstrating at block parties, and teaching fire safety to all ages. (WHFD.)

The community Christmas tree was presented to the town on May 13, 1929, by the Sarah Whitman Hooker Chapter of the Daughters of the American Revolution. The tree came from the Dewing Brothers farm on Mountain Road. For years, it was illuminated at Christmas, one of the traditions that everyone looked forward to. Remarkably, no one seems to know what happened to the tree, but one day it was gone. (WHPD.)

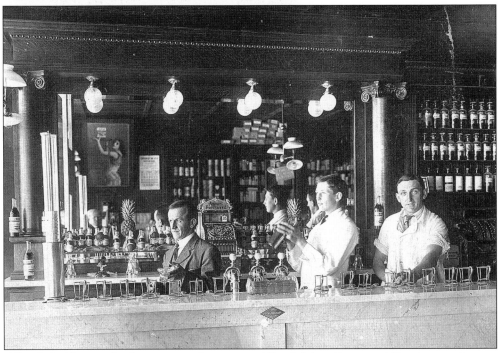

Allen B. Judd opened a drugstore on the corner of South Main Street and Farmington Avenue in 1899. Shown here is the soda fountain in the drugstore. It was West Hartford Center's first drugstore. (WHHS, 0050B.)

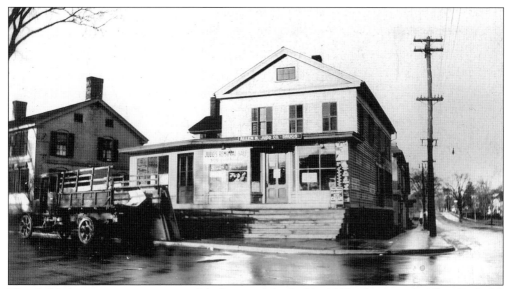

The Judd drugstore was so successful that on March 29, 1922, the owner, Allen B. Judd, demolished the old store to build the Judd Block, which still stands on the corner. Where the drugstore was located is today Bruegger's Bagels Bakery. (WHHS, 0050A.)

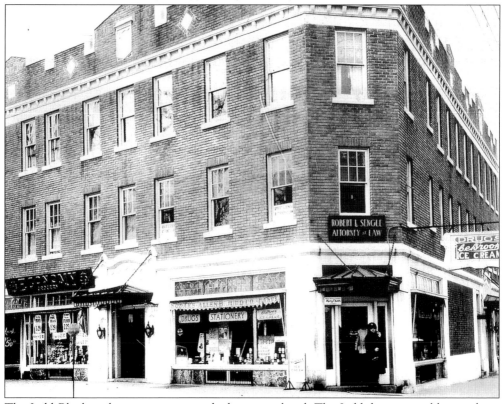

The Judd Block is shown as it appeared when completed. The Judd drugstore sold everything from drugs to stationery to ice cream. It continued until November 1926, when the owner sold the business to Whalen's Drug and retired. (WHHS, 0239N.)

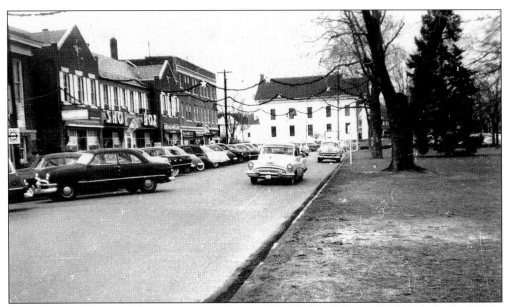

South Main Street by the green is pictured in the mid-1950s. The white building is the Congregational church, which served as the town hall until 1936 and was razed in 1957. The Judd Block is on the corner, followed by the Shoe Box Block, which also had the Hartford Electric Light store. There, one would turn in dead light bulbs and be given new ones for free. It was a promotional campaign to get one to use more electricity. (TOWH.)

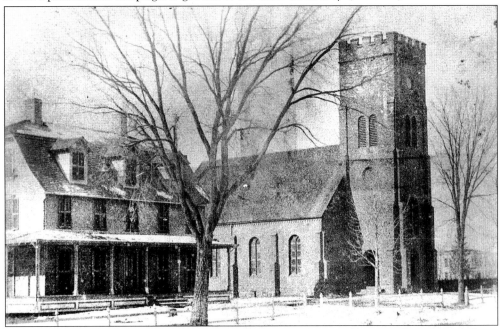

St. James Episcopal Church and its rectory stood at 13–17 South Main where Kaoud Rugs, Metzger's Lamp, Zacher's Photography, and Friendly's are located. The church was built in 1855. On October 1, 1953, the church sold the site to commercial developers and began raising the funds for a new building. The new church, at 19 Walden Street, was consecrated on Thanksgiving Day 1962. (WHHS, 0214F.)

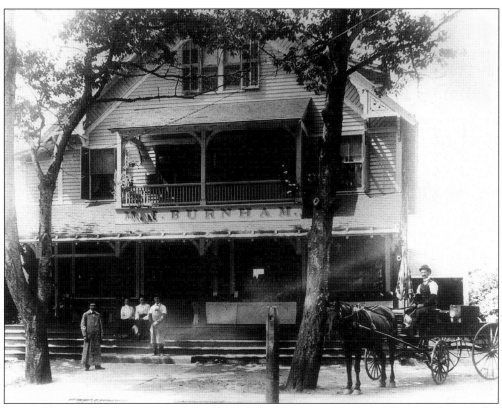

On April 4, 1898, Myron J. Burnham opened a grocery store at 19 South Main Street. This view of Burnham's was taken in 1901. (TOWH.)

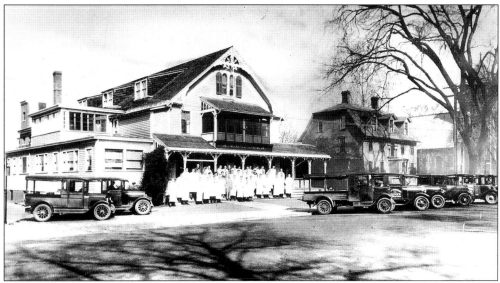

Over the years, Burnham's was so successful that the building was enlarged four times, and its gross sales grew from $27,000 to over $750,000. It employed over 70 people. The broad steps were used to display pumpkins, apples, and seasonal vegetables. This photograph shows the enlarged Burnham's in 1932. The St. James rectory and church are to the right. (WHHS, 00556.)

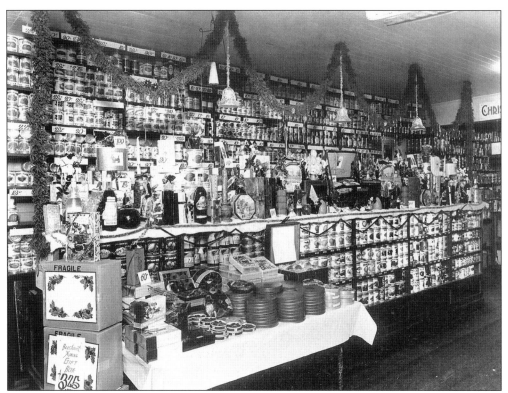

The interior of Burnham's at Christmastime featured festive displays. Customers could purchase fresh baked goods as well as an extensive range of groceries. Burnham's closed in 1959, and the building was torn down in August to make way for a modern First National Super Finast supermarket. (WHHS, 0053E.)

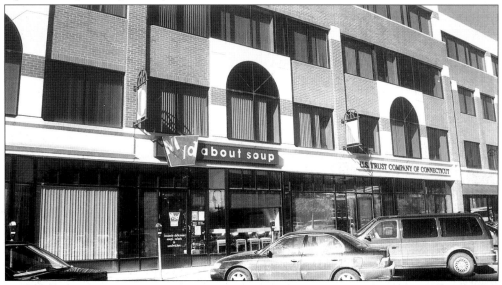

In 1987, the Finast closed and developer Seymour Sard purchased the site, razed the market, and built Town Center, the largest retail-office complex and parking garage in West Hartford Center. (WHHS.)

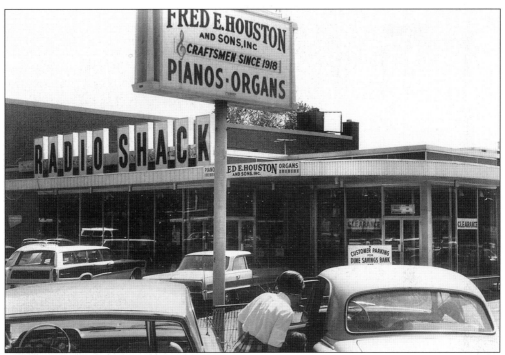

In December 1960, Radio Shack and Fred Houston and Sons opened in the modest complex just to the south of the Finast site. (TOWH.)

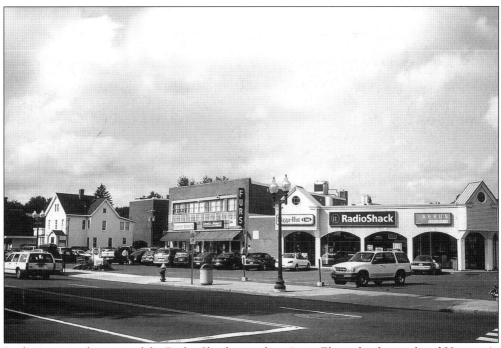

In this present-day view of the Radio Shack complex, Aerus Electrolux has replaced Houston's, and a Pizza Hut is now next to the Radio Shack. The white house to the left stands as a quiet reminder of a time when South Main Street was a residential area. (WHHS.)

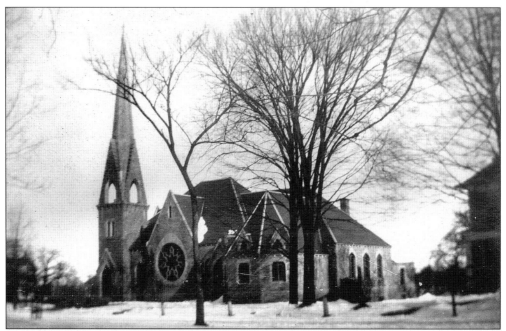

On the east corner of South Main Street and Farmington Avenue stood the Congregational church. It was the fourth meetinghouse of the congregation. It was built in 1882 in high Victorian style at a total cost of $33,437. (WHHS, 0231e.)

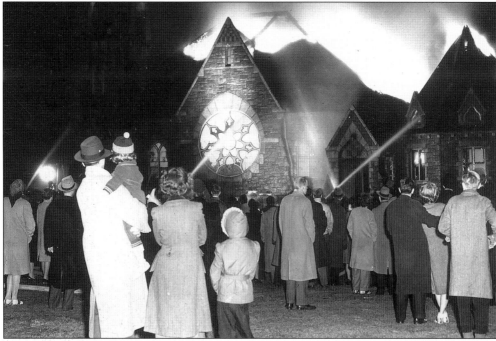

On the bitterly cold night of January 3, 1942, the granite Congregational church fondly remembered as "the greystone church" burned to the ground. Rabbi Feldman and his Temple Beth Israel congregation offered to share their facilities on Farmington Avenue with the Congregationalists until their new church was built. (WHFD.)

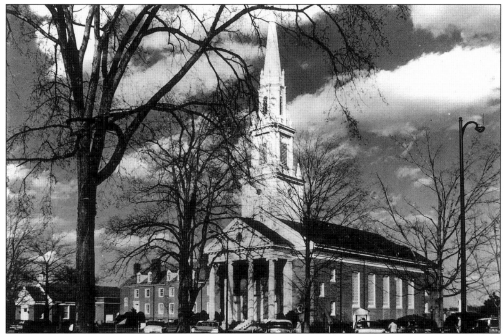

On September 21, 1947, the new meetinghouse of the First Church of Christ, Congregational was dedicated. As a special part of the ceremonies, in the morning at the church and in the evening at the synagogue, identical bronze plaques were unveiled and dedicated. The plaques celebrated Beth Israel's generosity in providing the First Church's congregation a place to worship until their new church was built. (WHHS, 0210.)

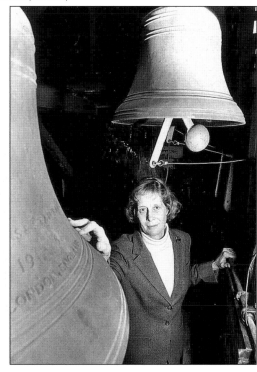

In April 1984, First Church added 26 more bells to its carillon of 24 bells in the white steeple. Joan Lovett, one of the church's six volunteer carillonneurs, poses beside one of the existing bells. (Copyright the Hartford Courant, reprinted with permission.)

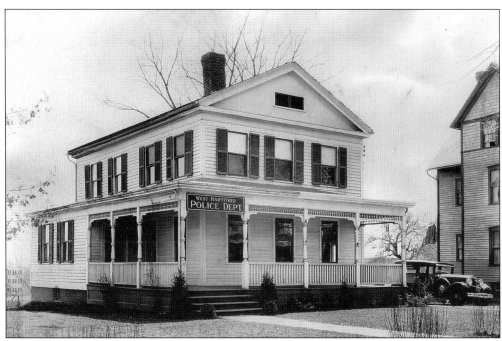

The first offices of the West Hartford Police Department were set up in the basement of the old town hall in 1919. On April 20, 1921, the department moved into this house at 12 South Main Street, where the Congregational church now stands. (WHPD.)

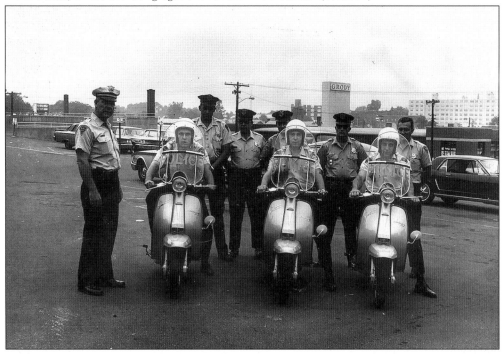

The first time the police department tried out its new scooters was on July 23, 1967. Seen at the rear of town hall, the officers are, from left to right, Captain Tully and Officers Mahoney, Pelton, Wilson, Marsden, Johnson, Stevens, Giovino, and Bockus. (WHPD.)

Korczak Ziolkowski saw Noah Webster as a hero and offered to carve a statue of him and donate it to the town. The project began in June 1921. Originally, Noah held a scroll in his left hand. In 1947, Ziolkowski moved to South Dakota and began work on the monument to Chief Crazy Horse. (WHHS.)

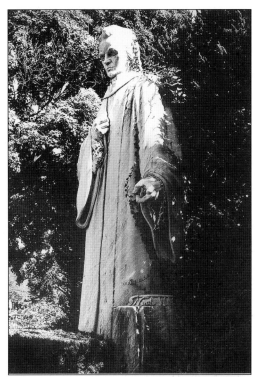

Raymond Road became car alley when Israel Grody opened Grody Chevrolet in 1934. Clayton Gengras's Ford dealership followed. In 1961, Newman's bought the Ford dealership and renamed it William's Ford. In 2001, Newman's closed the Ford dealership. On January 30, 2002, Crowley's lease on the Grody building expired and he relocated to New Park Avenue. There were plans in 2003 to develop this into the Blue Back Square, named for *Webster's Dictionary*. (WHHS.)

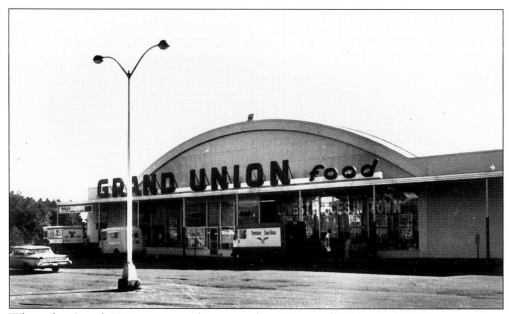

When the Grand Union supermarket opened at Crossroads Plaza in 1957, it was unique in design. Its arched roof meant that there would be no columns inside, thus allowing the market the freedom to place the goods in any configuration. The market has greatly expanded, absorbing the retail space to the south. Today, it is Waldbaum's. (WHTH.)

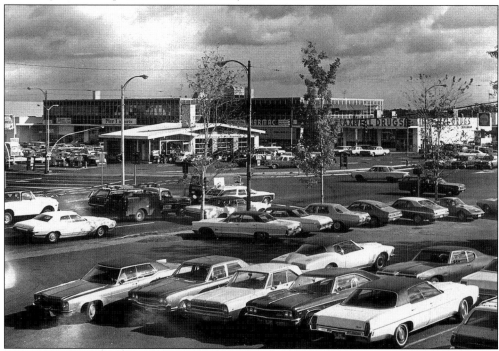

Crossroads Plaza is shown as it looked in November 1972. Maxwell Rulnick opened Maxwell Drugs in the center in 1946 and his fourth store here in 1957. The Maxwell space is today People's Bank and Kiddly Winks, which has "great stuff for kids." (Copyright the Hartford Courant, reprinted with permission.)

Two

BISHOPS CORNER

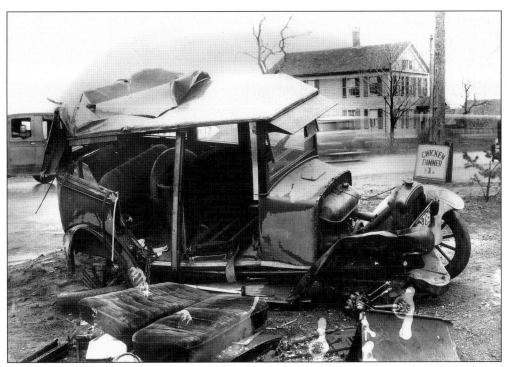

On the northeast corner of North Main and Albany Avenue stood Joseph Bishop's house (background) and tobacco business, which employed more than 50 people. This photograph, taken to record the car wreck, is the only known image of Joseph Bishop's house. There is a Shell gas station there today. The sign "Chicken Dinner $1" is for the Dutchland restaurant. In time, the area's name went from Bishop's Corner to Bishops Corner. (WHPD.)

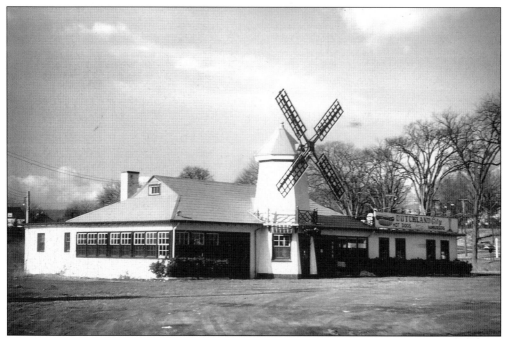

Dutchland Farms was the restaurant and dairy bar that stood in the open field where Marshall's and Fleet Bank are now located. One would go there for meals, hot dogs, ice cream, and pony rides. This was rural country in the early 1950s. (WHHS, 0253.)

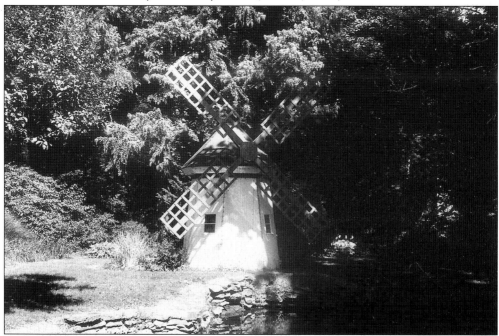

The Dutchland Farms site was purchased in 1950 by William A. Mauser, who planned to build an integrated shopping center to be anchored by Lord & Taylor. Dutchland Farms was demolished but not before its signature windmill was saved and moved to Gledhill Nursery, where it is today. (WHHS.)

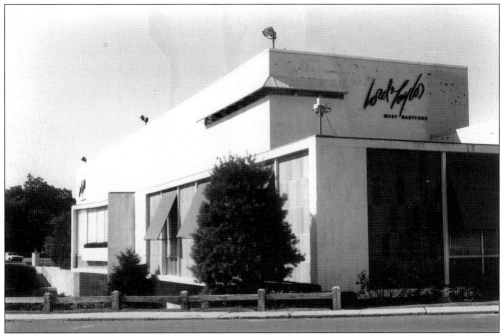

Lord & Taylor opened in April 1954 in this sleek modern building at Bishops Corner. Nearby were S.S. Pierce, F.W. Woolworth, the Doubleday Book Shop, Peck & Peck, and Harvey & Lewis. Kitchen Etc. and Macaroni Grill now fill those spaces along with the original tenant, Harvey & Lewis. (TOWH.)

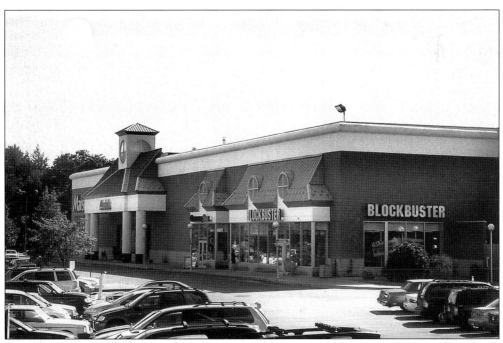

After Lord & Taylor moved to Westfarms in 1974, the space was remodeled for Caldor's. In 2003, it was home to Marshall's, Quizno's, Blockbuster, and Barnes & Noble. (WHHS.)

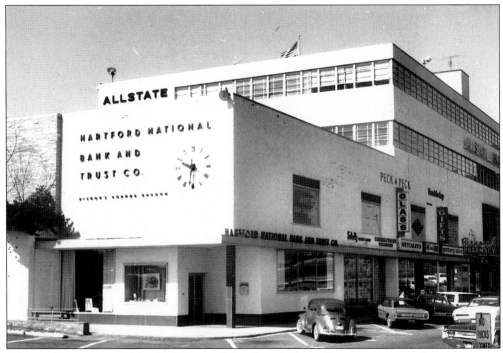

Allstate Insurance and Hartford National Bank and Trust Company were anchor tenants in the Bishops Corner retail complex along with Lord & Taylor and other stores. This is how the southwest corner looked in 1966. (TOWH.)

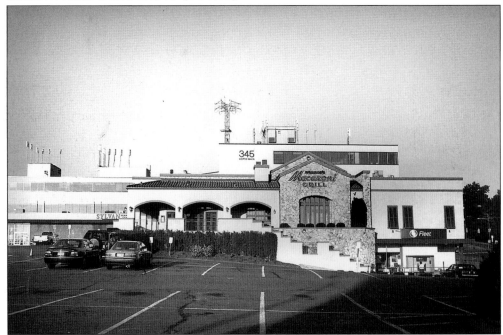

The same corner is shown after it was transformed for Macaroni Grill in the late 1990s. Note the presence of cell towers on the roof. Sylvan Learning Center is in the Woolworth space on the upper level. (WHHS.)

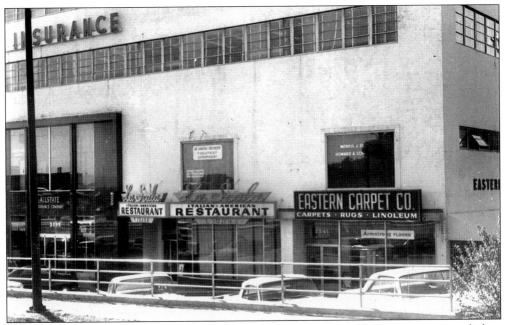

When the Bishops Corner complex opened in 1954, the lower level had more stores, including Metcalff Glass, the Grumbacher art supply store, and a Chinese restaurant. Later, LaScala and the Steak Club filled the restaurant space, among the scores of restaurants trying to succeed there. Today it is occupied by Buck a Book. (TOWH.)

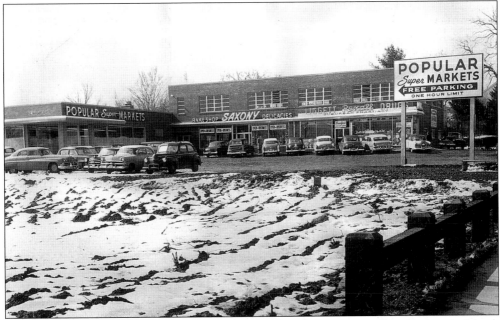

Farmland around Bishops Corner was quickly developed. On the southeast corner in March 1955, the Popular supermarket opened, along with Saxony Bakery and the Liggett Drug. In 1968, Popular moved to the new shopping plaza on the northwest corner of Albany Avenue and North Main Street, where Staples is today. The Crown took its place, today joined by Starbucks and Dry Kleaning by McKleans. (Copyright the Hartford Courant, reprinted with permission.)

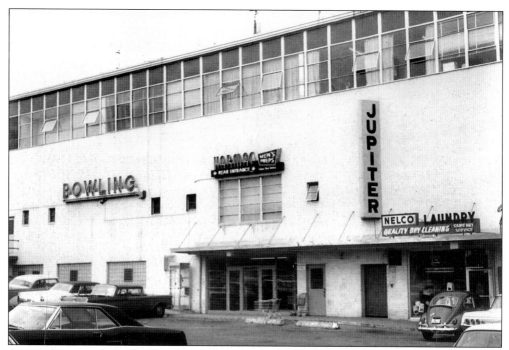

Across the street from the Popular market was the lower level of Crossroads Plaza. There was a bowling alley, Harmac, the Jupiter department store, Nelco Laundry, Mayrons Bakery, and restaurants. (TOWH.)

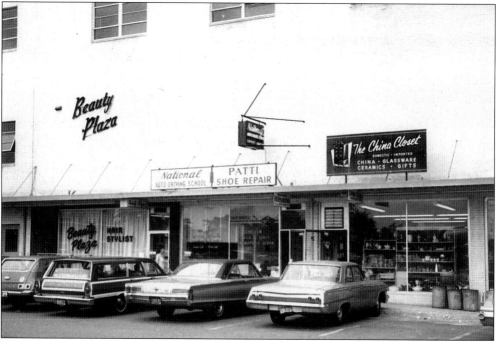

Crossroads Plaza also had the Beauty Plaza, National Driving School, Patti Shoe Repair, and the China Closet. Today, it is where one can find Mayflower Cleaners, Dotcom Wines, Vermont Gourmet, the Judaic Store, EBK Picture Framing, and Paul's Shoe Repair. (TOWH.)

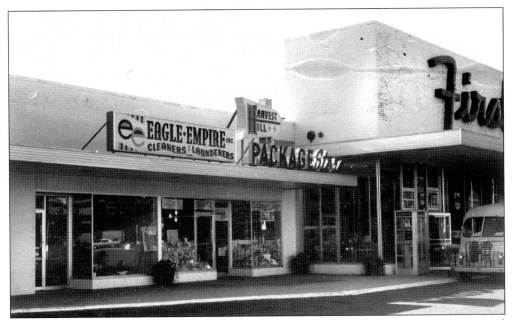

Across from Lord & Taylor, another shopping plaza was developed. It included First National (now Walgreens), the Harvest Hill Package Store (now Lox Stock and Bagels), a cleaners (now part of Bertucci's), and other establishments. (TOWH.)

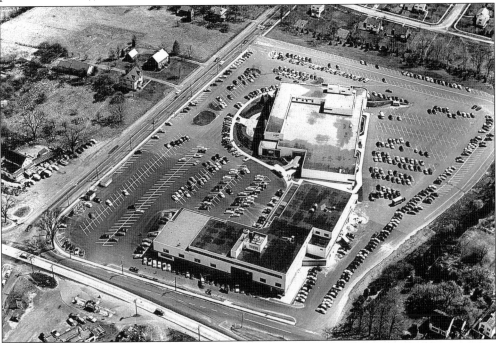

This photograph of the Lord & Taylor complex was taken on June 5, 1954. Of note is the building on the left with all the cars in front of it. This is Bon 'n Bills, the fruit and vegetable stand that had a live monkey in the fruit department. The fruit stand was replaced by the Society for Savings (now Sovereign Bank). This is the only known photograph of the store. (Copyright the Hartford Courant, reprinted with permission; photograph by R.B. Ficks.)

At 2575 Albany Avenue, just west of Bishops Corner, is the Albany Avenue Ornamental Iron Shop. It is owned and operated by Graham Jones, who is the third generation to operate the blacksmith shop on that site since 1900. (TOWH.)

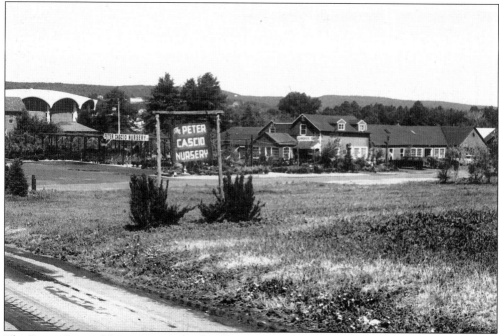

The Peter Cascio Nursery was a landmark at 2600 Albany Avenue from the 1940s until it closed in 1989. Moscarillo's Garden Shoppe has operated the site since then. (TOWH.)

Three

PARK ROAD

Park Road runs from Prospect Avenue to South Main Street. It was named as the street that led to Hartford's first park, South Green. The gentle terrain and streams made this area ideal for farming. In 1941, Allen C. Peterson founded A.C. Peterson Farms. The main plant and retail outlet were at 240 Park Road. Part of the plant space in 2001 was converted to the Park Road Playhouse. (WHHS, 0057E.)

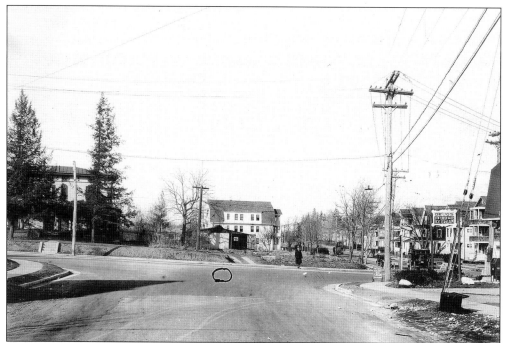

This is the corner of Quaker Lane and Park Road on November 14, 1927. The circle in the middle apparently marks the scene of an accident. The multifamily houses on the right are still there. A Shell gas station is now on the corner, and the elegant house to the left has been razed. (WHPD.)

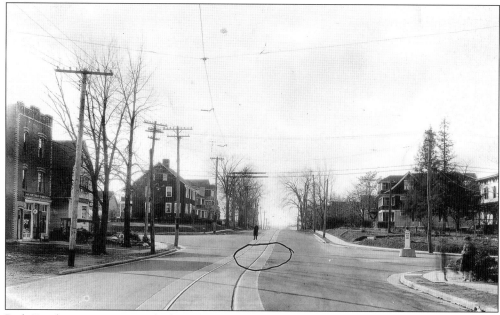

Park Road is seen in a view looking west to the intersection with Quaker Lane. On the left is Abelson's Market, where Hall's 2 Go is today. The white house on the corner was a drugstore and ice-cream store and is now Park Lane Pizza. The brown house on the southwest corner belonged to John and Katherine Hanily in 1957. The photograph is dated November 14, 1927. (WHPD.)

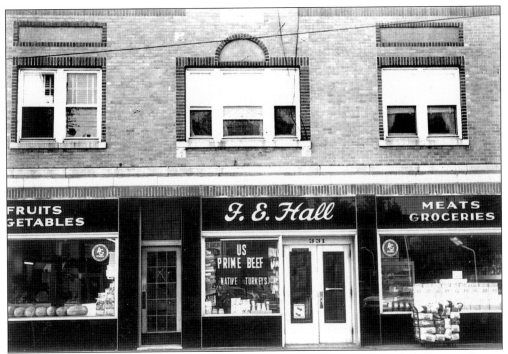

The F.E. Hall market has been at 331 Park Road since Franklin Edward Hall opened it in 1935. In 1967, the Booth family purchased the market from Hall. Today, Ron Booth owns and manages the store. (TOWH.)

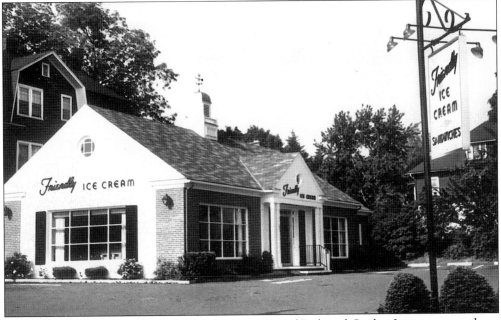

The brown house (page 54) on the southwest corner of Park and Quaker Lane was torn down in December 1957 for the building of West Hartford's first Friendly's. It is the first, beating out the Friendly's on New Britain Avenue (page 71) because this one opened on July 23, 1958, five months before the other one. The store is now serving pizza as Barb's Pizza. (TOWH.)

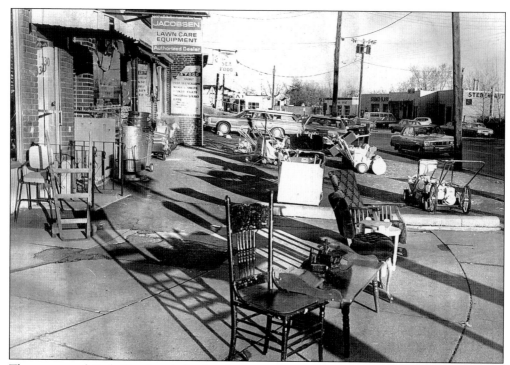

The corner of Park Road and Quaker Lane is shown as it appeared in December 1976. (Copyright the Hartford Courant, reprinted with permission; photograph by John Long.)

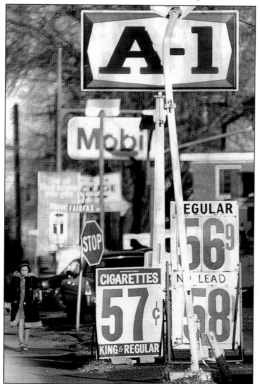

In December 1976, the East Side Study Committee reported to the town that the the area was dominated by signs like the ones seen here. Since then, Park Road has greatly improved and is now a shopping area. Note the price of gas and cigarettes. (Copyright the Hartford Courant, reprinted with permission; photograph by John Long.)

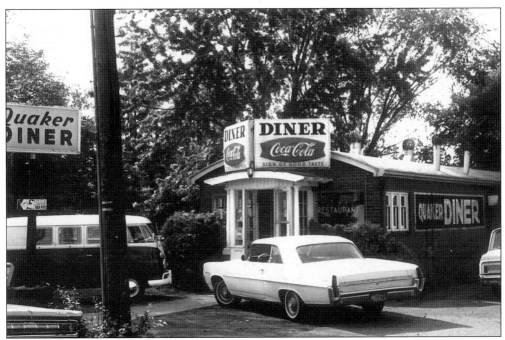

The Quaker Diner, seen here in 1966, was opened at 319 Park Road in 1931 by Harry Bassilakis. Except for the style of the cars, it has changed very little. The original owner's grandson is again in charge of the diner. (TOWH.)

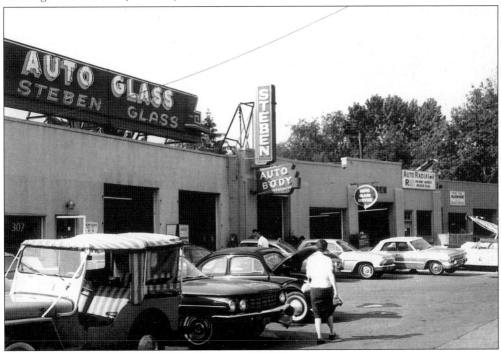

Part of the charm of Park Road is that many of the businesses have been there for many years. Steben Glass was opened in 1956 by Raymond and Roland Steben. Today it is managed by Raymond's sons David, Paul, and Peter Steben. (TOWH.)

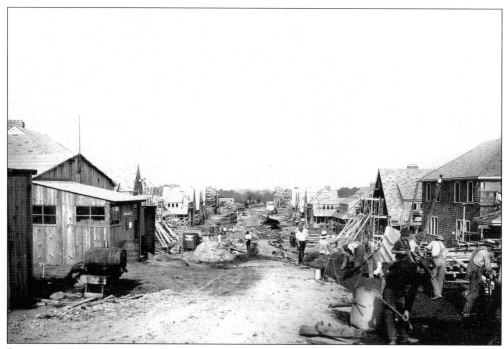

Between 1910 and 1930, the town grew from 4,808 to 24,941. As a result of this dramatic growth, many houses were built. Washington Circle, north of Park Road, is a series of two-family houses in a parklike setting. It was proposed as a subdivision in July 1920, and the street was accepted by the town in February 1921. Above is the circle under construction, and below is a view of some of the newly completed homes. (WHHS, 0251a-1.)

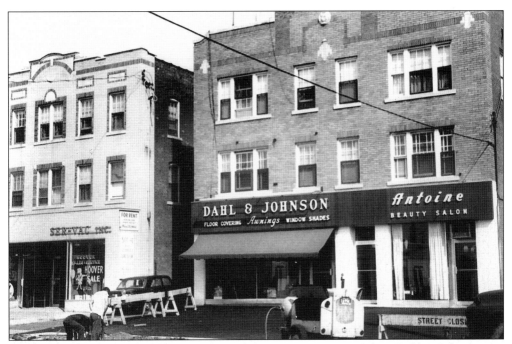

At 272 Park Road were Dahl & Johnson and the Antoine Beauty Salon. Dahl & Johnson was the place to go to get the finest quality in custom shades and awnings at reasonable prices. In 2003, the YCHCA Thrift Shop was in the building on the left and Kimmy's Nails on the right. (TOWH.)

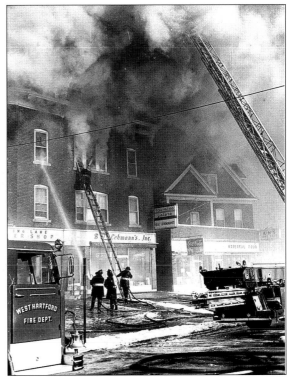

Bill Lehmann's paint and wallpaper building, at 208 Park Road, suffered a major fire on the night of February 8, 1972. The business regrouped and continued to serve for many years. It is still sells paint as Sayadoff Paint and Wallpaper. (WHFD.)

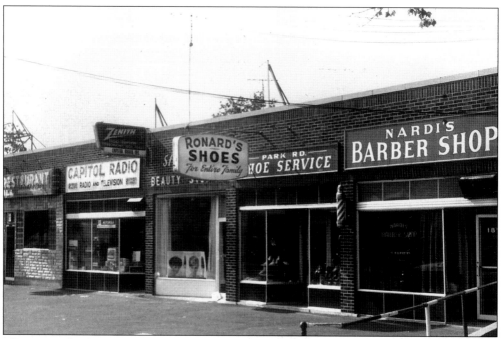

This 1966 photograph shows the building at 185 Park Road, which included a restaurant, a radio and television store, a beauty salon, a shoe store, and a barbershop. Later, the individual stores moved out and the Brickyard Pub moved into the entire space. In 2003, it was waiting to become Chengdu Asian Restaurant. The Junior League Clothes Horse Store is on the left corner. (TOWH.)

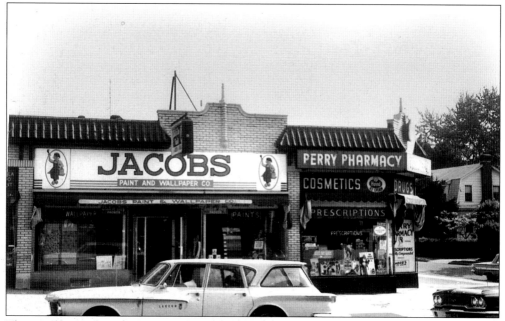

The retail part of Jacobs Paint and Wallpaper was founded by Eddie Jacobs in 1946. In 1956, the establishment moved to 132 Park Road, where it still stands. This is indeed the land of steady habits. (TOWH.)

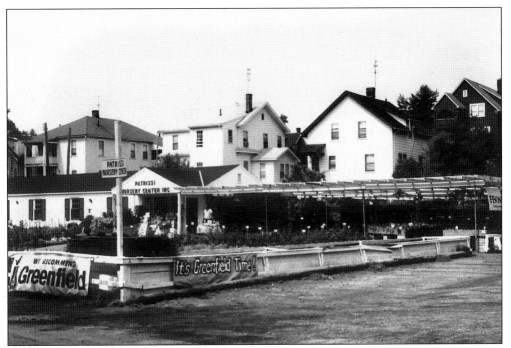

The Patrissi Nursery Center was founded at 35 Ringgold Street in 1949 by Frank A. Patrissi. His son Richard, who has been a prime mover of all good things at Park Road, ran the business and retired from the business in 1997. Today, Partissi's is still in full operation on Ringgold Street under the leadership of Rocky Goodwin and Kevin Cavlier. (TOWH.)

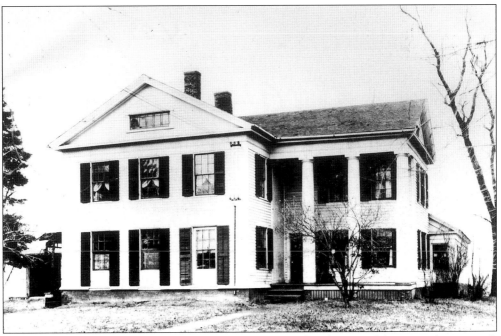

The Bissell homestead was built on Park Road in 1858. Little is known of the owner, but it stands as an elegant statement of the fine homes that were once on Park Road. (WHHS, 0159.)

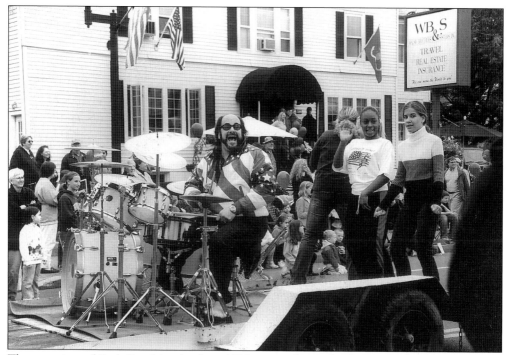

The repaving of Park Road in the late 1990s seemed to take forever. When it was finally completed in 1999, Angelo Faenza, Richard Patrissi, and Patrick Daly created an old-fashioned parade to mark the event and to bring shoppers back to Park Road. Rob the drummer is a favorite with his message to teens about substance abuse and being substance free. (Patrissi.)

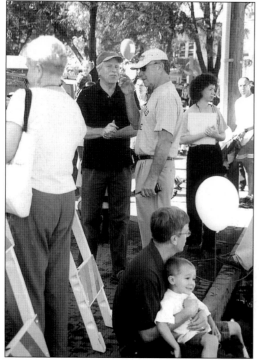

Dan Kain of WFSB Channel 3 gets his final instructions from parade co-founder Richard Partissi (right). Rene McCue of West Hartford (right) preferred to watch the parade, held on October 4, 2003. It was the fifth annual Park Road parade. (Patrissi.)

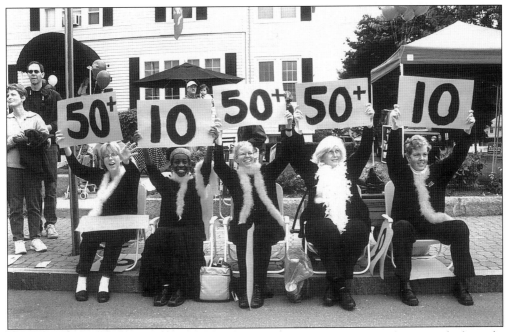

For the 2003 parade, the Wacky Women of Whiting Lane decided to judge instead of march. Dressed in black with screaming pink-and-purple boas and pink-and-purple signs, they rated the groups as they passed by their informal reviewing stand. (TOWH.)

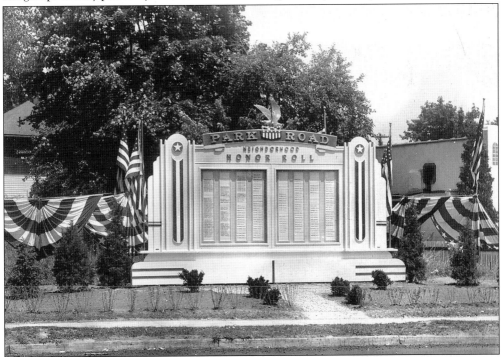

During World War II, the Park Road neighborhood erected this special honor roll to list all of its residents who were fighting in the war. The monument stood at the corner of Park Road and South Highland Street. It was taken down at the end of the war. (TOWH.)

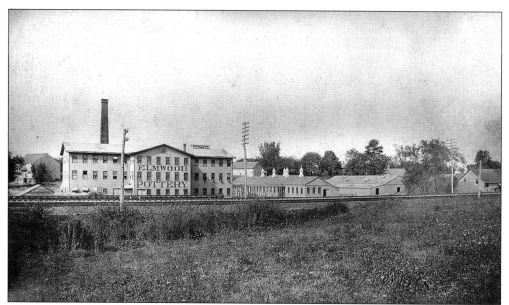

Seth and Thomas Goodwin established Goodwin Pottery in Elmwood along New Britain Avenue in 1798. Through the years, the factory expanded and survived fires in 1822 and 1867. In 1868, descendants erected this three-story pottery along New Britain Avenue near the railroad. It employed more than 80 people and had steam-powered potters' wheels and three kilns. Besides pottery, it produced terra-cotta products and fine china. A fire in 1908 ended the business. (WHHS, 0242D.)

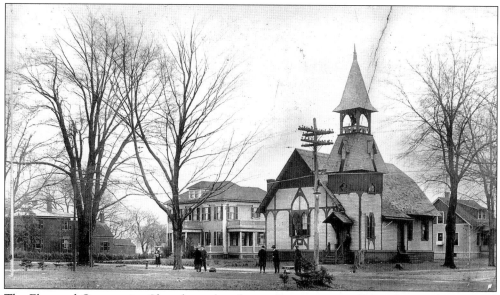

The Elmwood Community Chapel stood at the southwest corner of New Britain Avenue and Grove Street. It was built in 1876. Elmwood was an industrial area and as such developed a close community sense with its own post office, schools, stores, and this church. In 1921, it became the Elmwood Community Church, on Newington Road. (WHHS, 0293.)

Four

ELMWOOD, THE MALLS, AND THE CHARTER OAK RACETRACK

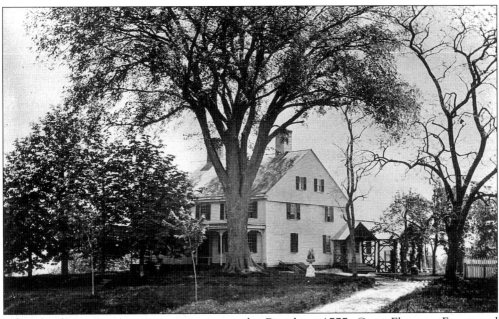

After the first great American victory over the British in 1777, Capt. Ebenezer Faxon and others planted elms at the corner of New Britain Avenue and South Quaker Lane. The mature trees were so majestic that the community around it became known as Elmwood. At 1237 New Britain Avenue is the Sarah Whitman Hooker House. Built *c.* 1726, it housed British officers captured in the American Revolution. It is open to the public. (WHHS, 0121B.)

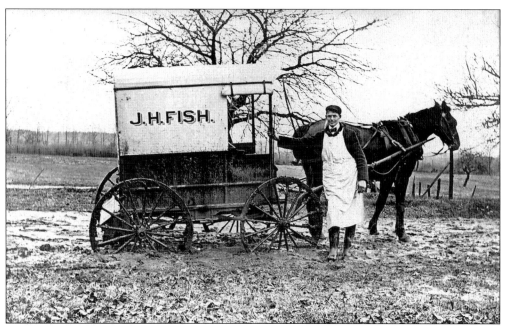

Early industries in Elmwood included J.H. Fish, on Newington Road. The specialty of the business was not fish but choice meats. Note how the cart is sinking in the mud. Roads in West Hartford were not graveled or paved until 1890. (WHHS, 0026b.)

The home of H. Burdette Goodwin was on New Britain Avenue, east of Quaker Lane, near where the Elmwood Community Center is located today. The people posing in front of the house appear to be the Goodwin children, who clearly wish they were elsewhere. (WHHS, 0018.)

This old gristmill was part of the Beaches' Vine Hill Farm. This view, looking south, shows the west side of Quaker Lane near Trout Brook. The roads in the area have been greatly reconfigured, but part of the farm is now Beachland Park. (WHHS, 0057A.)

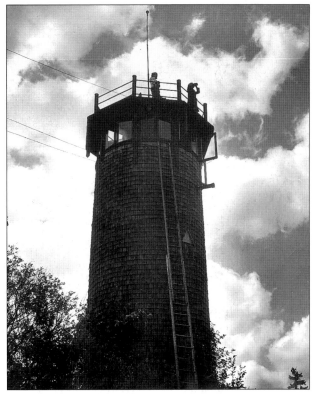

During World War II, the Vine Hill Farm's water tower was an ideal place to spot enemy aircraft. (WHHS, 0190.)

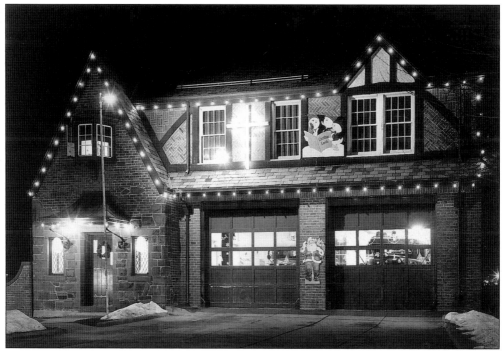

The West Hartford Fire Station No. 3 stood on New Britain Avenue. Here it is shown in the 1960s, decorated for Christmas. (WHHS, 0281f.)

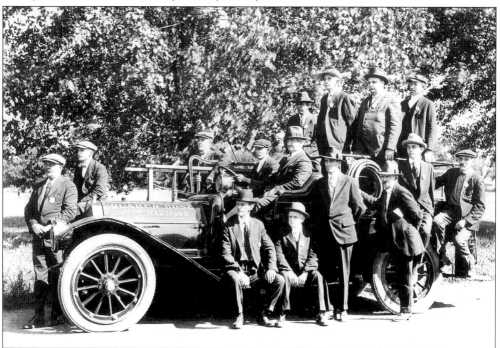

Quaker Hose No. 3 was driven by James J. Stewart (at the rear with the cap and mustache). The photograph has a note: "Taken [in the] fall of 1921 for program minstrel and dance, 2-21-22." They are clearly posing for something. (WHHS, 0204.)

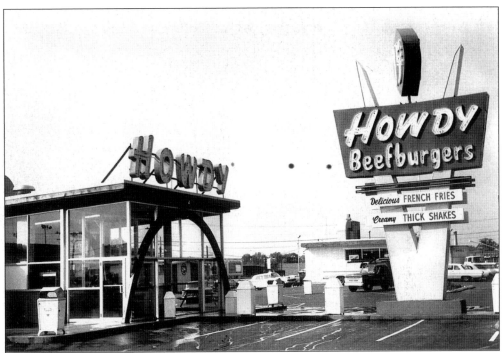

On New Park Avenue were the Howdy hamburger stand and, to the south, the Dunkin' Donuts and the Shell gas station, which was on the corner of Flatbush. This is how the stores looked on June 17, 1966. Howdy is gone, replaced by Acme Auto, but Dunkin' Donuts and Shell are still there, although both have been remodeled. (TOWH.)

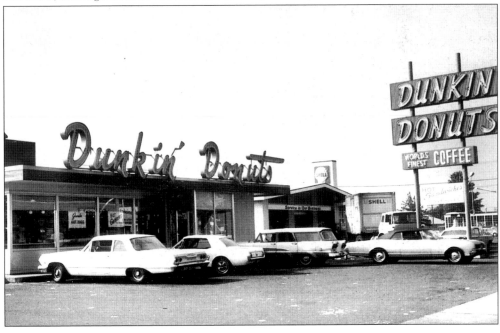

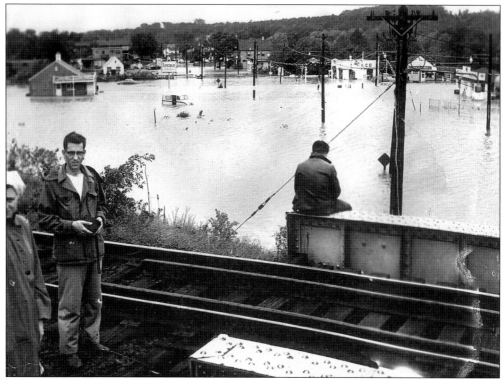

The August 1955 hurricane devastated West Hartford. This photograph was taken from the railroad bridge on New Britain Avenue, looking east. As a result of the floods, a flood-control task force was formed. Their work greatly altered Trout Brook and other streams but has helped keep the town dry. (WHHS, 0123B.)

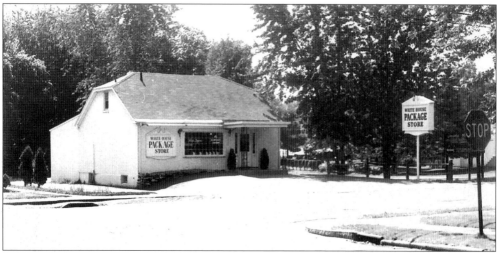

In 1964, Bruce Goldberg opened the White House liquor store in this small white house on Newington Road. With time, energy, and zany attention-getting promotions, the store moved in 1975 to a new and much larger building next door, at 178 Newington Road. The promotions and hard work paid off, and in 1987, Crazy Bruce's enlarged that building, putting Bruce's face and name on the colorful facade. (TOWH.)

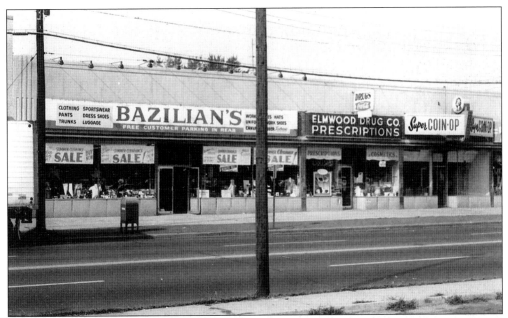

Bazilian's was founded in Hartford in 1930 and moved to 1109 New Britain Avenue in 1956. The building was constructed in 1940. Next door were the Elmwood drugstore and Super Coin-Op. In 1970, Bazilian's moved to Park Road and, in March 2003, began selling only shoes. At the New Britain Avenue location in 2003 were Jerry's Artarama Deluxe Liquors, Pro Nails, and the Fernwood Restaurant. (TOWH.)

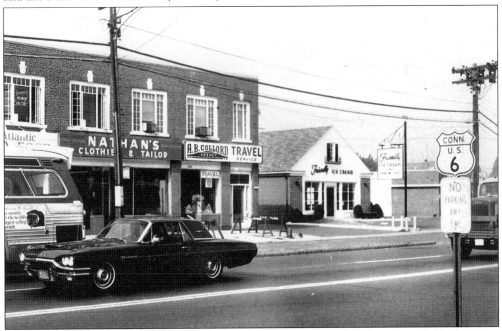

Where the Elm Community Chapel stood (page 64) on the southwest corner of New Britain Avenue and Grove Street in 1966 were Atlantic Sea Food, Nathan's Clothiers, and A.B. Collord Travel Services. Beyond is the Friendly's restaurant that opened on December 4, 1958. It was the town's second Friendly's by five months. It is still serving customers. (TOWH.)

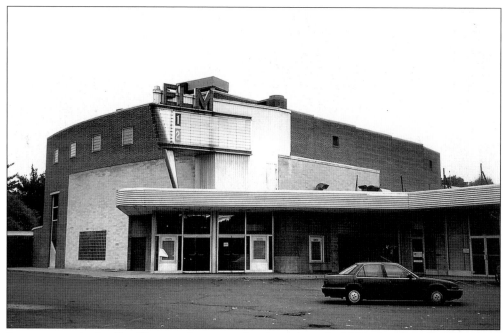

For many years, the Elm Theater plaza was a bustling place. In 2003, the Elm closed its doors and the plaza became deserted. (WHHS.)

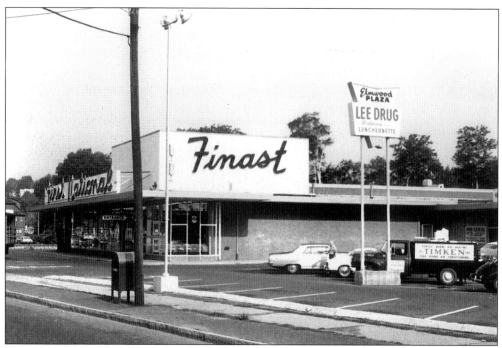

On the north side of New Britain Avenue was the First National Finast supermarket in the Elmwood Plaza. In 2003, the Puppy Center, Subway, and Fuji Sushi occupied market's space. (TOWH.)

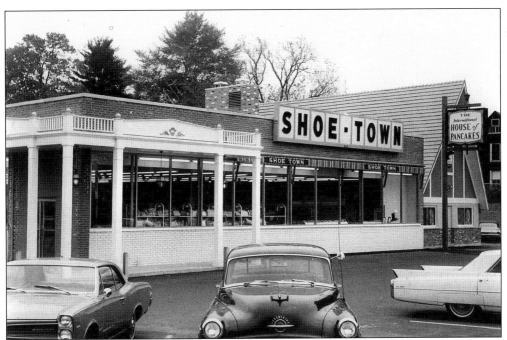

At the top of the hill at 1244 New Britain Avenue in 1966 were Shoe-Town and the International House of Pancakes. In 2003, Harstan's Jewelers had moved in and IHOP was still serving pancakes. (TOWH.)

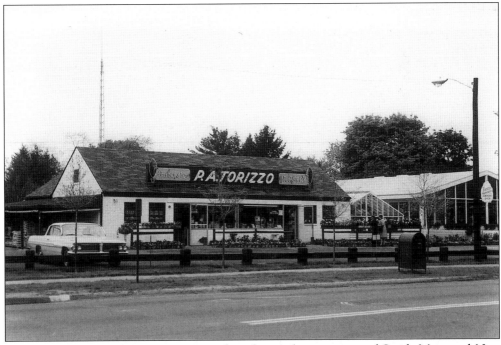

For years, the R.A. Torizzo nursery stood at the southwest corner of South Main and New Britain Avenue. In the 1990s, the nursery was sold and a new plaza replaced it, the home of Munson's Chocolate and Blockbuster. (TOWH.)

It is hard to imagine that until 1960 the area west of South Main Street and New Britain Avenue was open farmland. This picture shows the Philip Corbin farm and homestead on the southwest corner of New Britain Avenue and South Road. In 1974, this became Westfarms Mall. (WHHS, 0119E.)

The Gerth dairy farm occupied the extensive acreage from New Britain Avenue and South Main Street to South Road. The land was flat and extended as far as the eye could see. On March 21, 1961, some 20 acres of the Gerth farmland became the home of Sears and the Corbin's Corner Parkade. The parkade had 31 stores with over 130,000 square feet of retailing. The name refers to the Corbin farm, which was across the road. (WHHS, 0057B.)

74

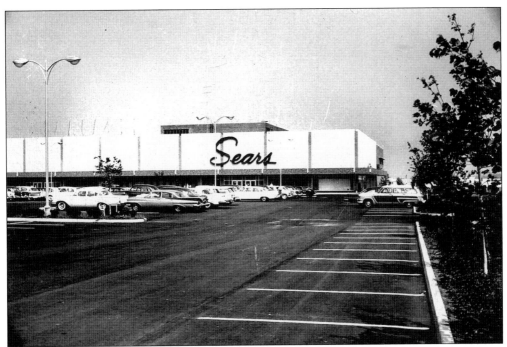

When Sears opened in August 1961, it was the first major store to be built in West Hartford since the completion of Lord & Taylor at Bishops Corner in 1954. (TOWH.)

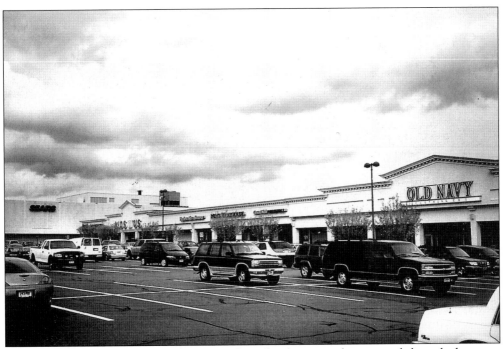

The early Corbin's Corner Parkade next to Sears has been greatly improved through the years. The strip mall's roofline was enhanced with architectural false fronts reminiscent of the Old West. In 2003, the mall was home to Old Navy, Toys R Us, and other establishments. (WHHS.)

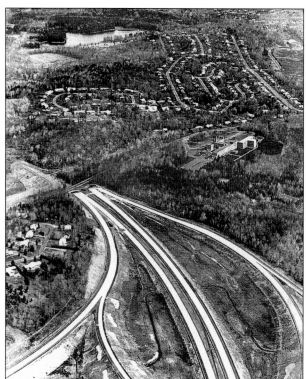

Interstate 84 cut a wide path through West Hartford. Begun in the 1960s, it was not completed until 1969. One part that was built but remained unused for years was "the Stack," the levels of roadway west of Westfarms that was to connect Interstate 84 and Interstate 291. With the patience of the Connecticut Department of Transportation, Interstate 291 south of the Stack was finally completed in the late 1990s. (WHHS, 0644A.)

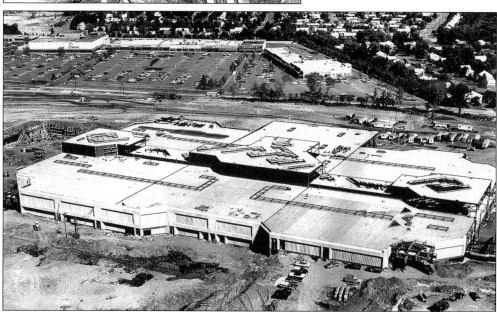

Joseph Vetrano and Richard Sheehan conceived of Westfarms in 1965, but legal roadblocks stalled it. Westfarms began in the spring of 1971, and the 85-store complex opened in October 1974. This view, looking northeast, shows Westfarms on September 10, 1973. Some of the early anchors, G. Fox & Company and Sage Allen, are now but memories, but Lord & Taylor has been joined by Nordstrom's. In the background are Sears and Corbin's Corner Parkade. (Zaremba Photography, Eagle Roof Inc., the Taubman Company.)

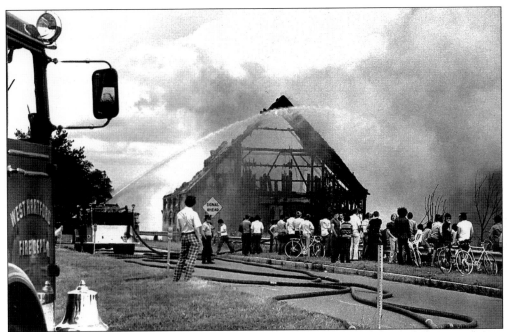

This is the last remaining barn of the Gerth farm, which once ran from South Main Street and New Britain Avenue to South Road. For years, the structure stood quietly beside Interstate 84. On August 10, 1972, it fell victim to a spectacular blaze that could be seen for miles. (WHFD.)

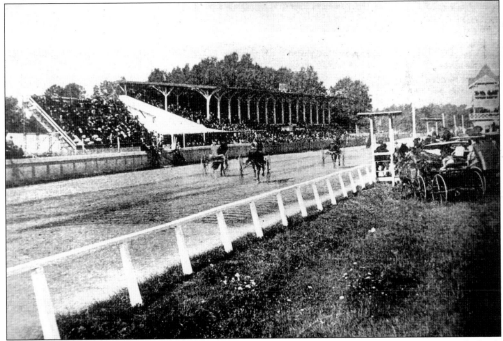

The Charter Oak racetrack occupied the 120-acre tract bound by South Quaker Lane, Flatbush Avenue, and Oakwood Avenue. It opened in 1873 and drew thousands for the daily summer trotting races. It was founded by Burdette Loomis and backed by Charles M. Pond, of Elizabeth Park, and Morgan G. Bulkeley, president of Aetna and governor of the state. (WHHS, 0094A.)

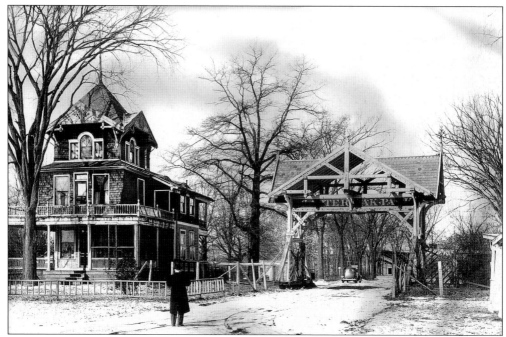

When the legislature banned betting, Charter Oak Park developed part of its land into Luna Park, "West Hartford's Coney Island." It held races and had a midway and rides and other attractions. (WHHS, 0071A.)

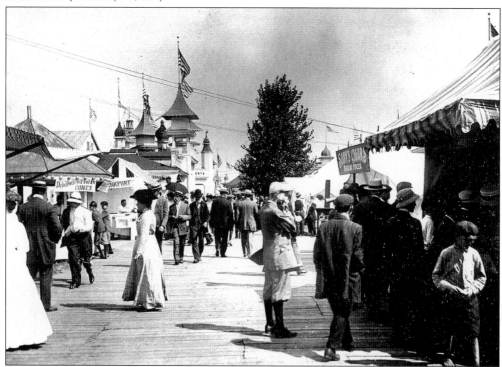

The midway at Luna Park sold everything from ice cream to cigars to hot dogs. There were rides, clowns, and acts to entertain. It was the place to be in the summer. (WHHS, 0073C.)

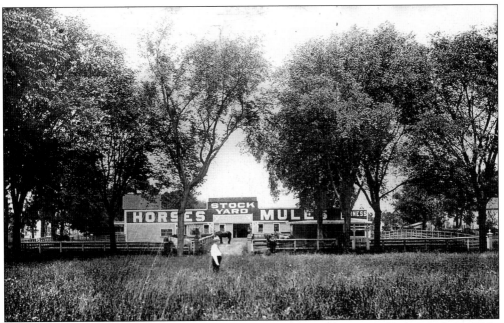

Part of Charter Oak Park was a stockyard where horses and mules were held. (WHHS, 0093B.)

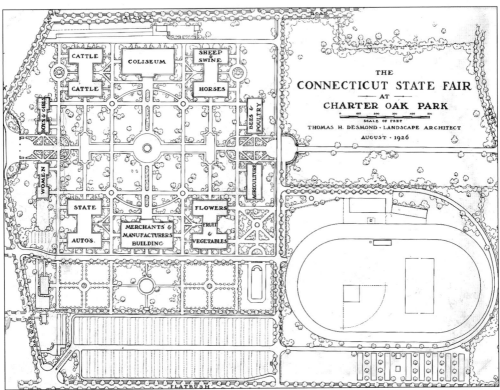

In 1926, Charter Oak Park became the Connecticut State Fair. This plan by Thomas Desmond outlined the proposed use of the acreage while still preserving the racetrack. Flatbush Avenue is on the bottom, and Oakwood Avenue is to the left. (WHHS, 00866.)

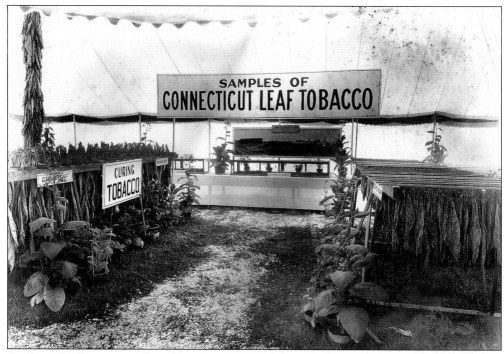

At the 1926 Connecticut State Fair, there were exhibits of state products, including samples of Connecticut leaf tobacco. Shade tobacco is used as the wrapper for fine cigars. (WHHS, 0088A.)

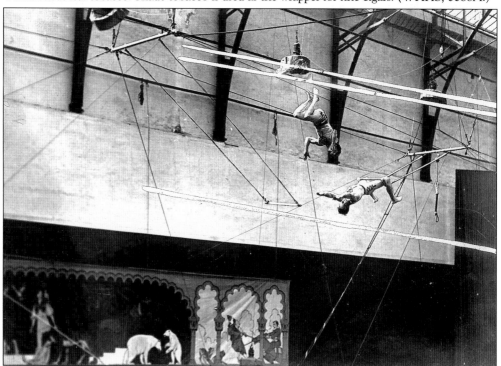

The performers at the Connecticut State Fair in 1926 included the Flying Codonas. (WHHS, 0084A.)

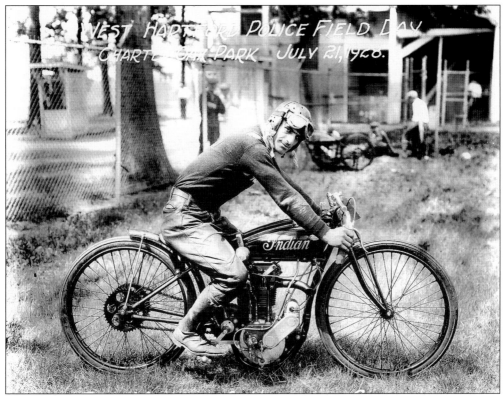

The West Hartford police held a field day at the Charter Oak Park beginning in 1926. Events included amateur and professional motorcycle races, entertainment, a concert, and "Singing, Dancing and Whoopee" until midnight. One of the racers on July 21, 1928, was Fred Marsh of Hartford, who competed for prizes. (WHPD.)

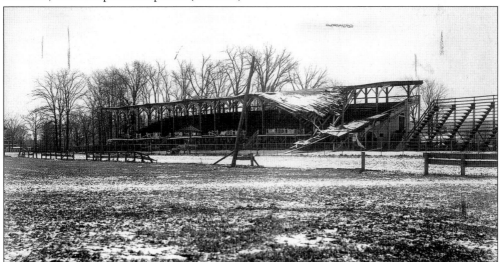

In time, the park fell into disrepair and was no longer used for exhibitions or events. This view shows the grandstand in March 1937. The land was offered to the town, which turned it down. Even today, as you stand on Flatbush, you can see the stately line of oaks in neat rows that once lined the racetrack. (WHHS, 0078F.)

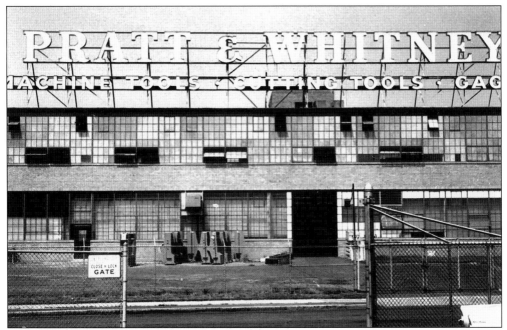

In February 1937, Pratt & Whitney acquired the Charter Oak Park's land. The new factory entrance replaced the old Luna Park Gate. The factory was 700,000 square feet and had over 110,000 panes of glass. In 1996, the deserted factory was razed and a BJ's Warehouse and Home Depot occupied the site. (TOWH.)

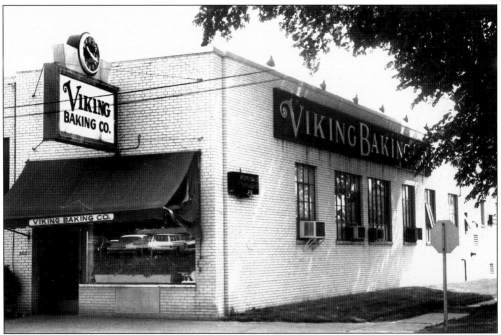

For years, Viking was at 500 Oakwood Avenue. The bakery was founded in 1928 by Arvid Marcuson, and it moved several times before settling in across from Luna Park. Its Swedish limpa was legendary, and it also made Mark Twain's recipe for sweet mince cake. (TOWH.)

Oakwood Avenue runs from New Britain Avenue to Kane Street. In 1940, it was greatly widened. To celebrate the completion of the work, the residents held a parade in October. Home-grown parades, such as the Park Road Parade, are the best. (TOWH.)

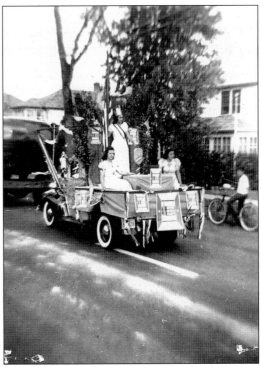

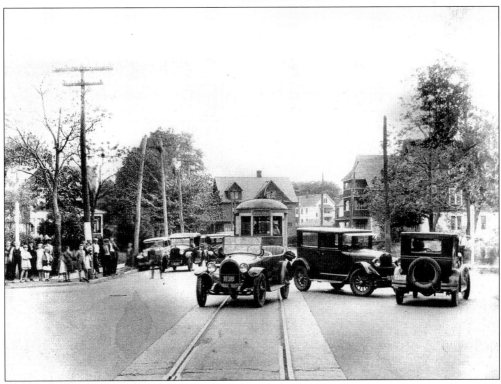

This is the corner of Park Road and Oakwood Avenue. A crowd has gathered to see how this situation involving a trolley and some automobiles will be resolved. (WHPD.)

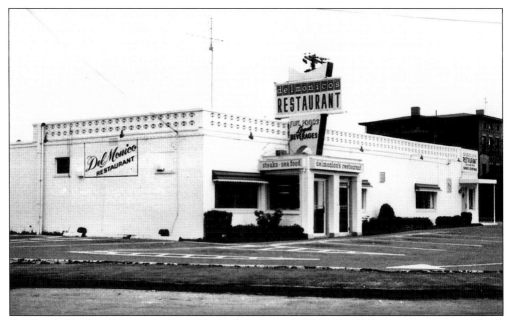

On South Quaker Lane across from Flatbush in June 1966 was Del Monico Restaurant, which featured steaks and seafood. Other restaurants have tried and failed to succeed there. In 2003, the restaurant was again up for sale or lease. (TOWH.)

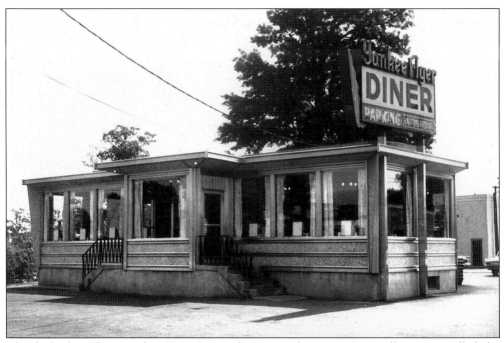

This little diner has stood at 536 New Park Avenue for years. Originally, it was called the Yankee Flyer Diner. This photograph was taken in 1966. (TOWH.)

Five

FARMINGTON AVENUE

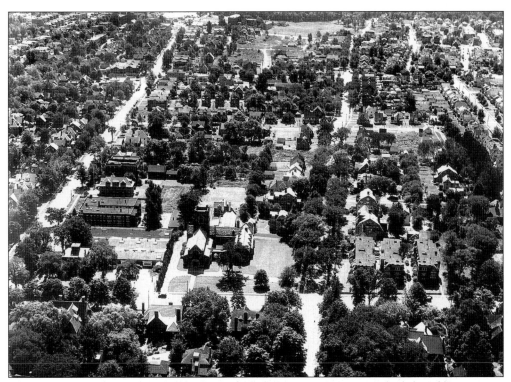

This aerial view of West Hartford looks south with Prospect Avenue on the left and Farmington Avenue on the bottom. St. John's Episcopal Church is in the lower center. The photograph was taken after 1928, as the church is shown with its main doors on Farmington Avenue. Temple Beth Israel, which was built in 1936 to the right of the apartment buildings, is not there. (Curtiss Wright Flying Service Inc., Aerial Survey Division; St. John's Episcopal Church.)

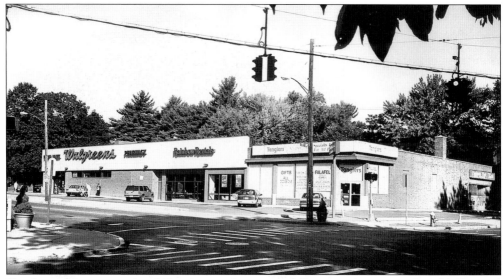

On the northwest corner of Farmington Avenue and Prospect Avenue is the old Concord Pharmacy building. For years, the A&P was where Walgreens is shown, followed by Clapp & Treat sporting goods and Fashion Flair (now Rainbow Rentals) and the Concord Pharmacy (now Tangiers). Edward and Nancy Latif opened Tangiers in 1996. Its falafel is phenomenal. (WHHS.)

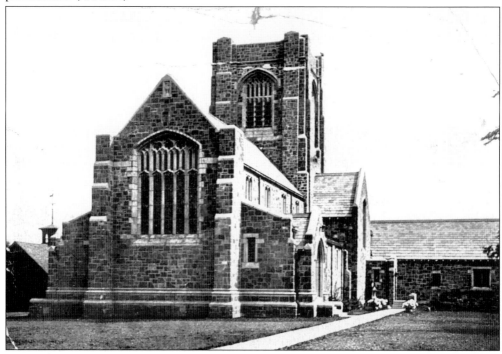

St. John's Episcopal Church moved from Hartford to 679 Farmington Avenue in 1909. The new church was designed by Bertram G. Goodhue, but the parish could afford to build only part of his design. This photograph shows the newly completed church, the first phase. Note that the entrance is on the side and does not have the center doors below the great window. It was another 20 years before the building was finished. (St. John's Episcopal Church.)

In 1936, the Congregation Beth Israel dedicated its new temple at 701 Farmington Avenue. The architect of record was Charles R. Greco, who specialized in Byzantine designs. In reality, the person who guided every aspect of the new temple was Rabbi Abraham J. Feldman. The bima in the main sanctuary reflects the curves of the distinctive dome atop the 12-sided building. The ark and altar are made of Algerian veined onyx. (Photograph by Stephen Dunn.)

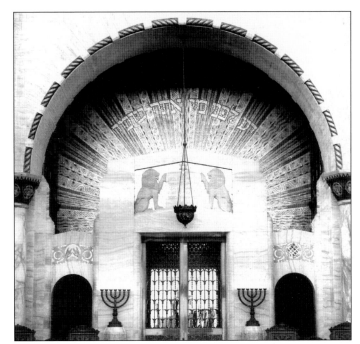

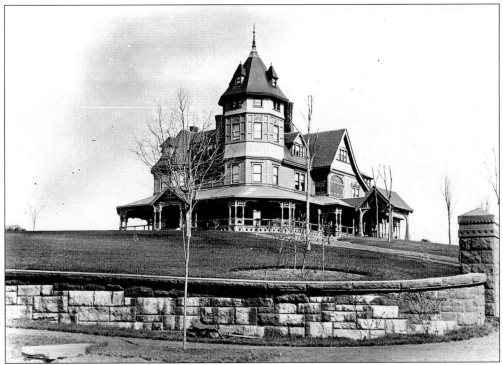

On Farmington Avenue (in what is today West Hill Drive) was the Cornelius J. Vanderbilt mansion, built in 1879. Vanderbilt never moved in, and in 1882, Ira Dimock, a silk manufacturer, bought it. Dimock's daughter Edith married the painter William Glackens. In the 1920s, the mansion was razed and the land was developed by Horace R. Grant and Stanley K. Dimock. (WHHS, 0189b.)

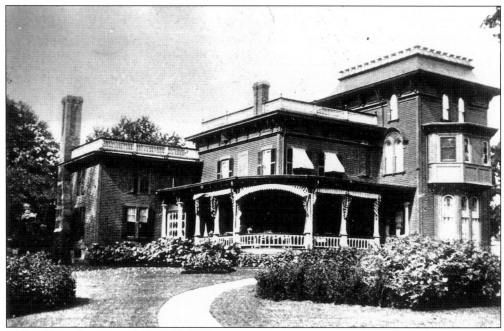

The Judd mansion stood at 29 Highland Street. Its property extended all the way to Concord Street. In time, such great old mansions were either razed or converted into funeral homes or convalescent homes. The Judd mansion became Sloan's Convalescent Home, for "post-operative patients, the nervous and those needing rest." (WHHS, 0177a.)

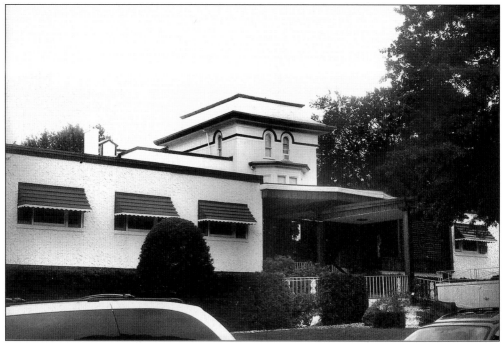

In January 1961, Sloan's became Hughes Convalescent and Rehabilitation, and great wings were added to the mansion. The building does survive and is used primarily for administrative offices. (WHHS.)

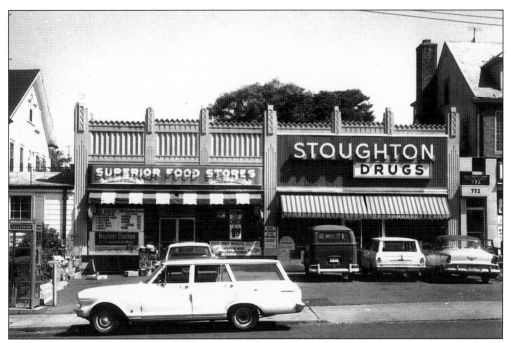

The building at 774 Farmington Avenue was the home of the Superior market and Stoughton Drugs. The Superior location was where Morris Joseloff opened his first First National market in 1933. It grew into the Finast supermarket chain. (TOWH.)

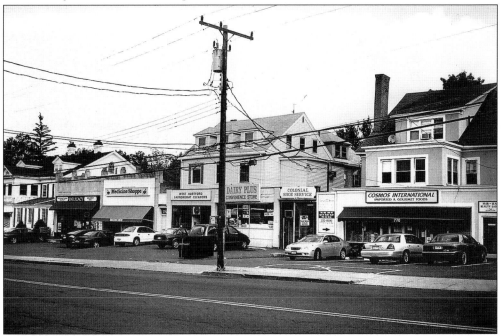

The same block is shown as it looks today. The Superior market is gone, replaced by a small market and delicatessen. The Stoughton Drugs space is still a pharmacy under the banner Medicine Shoppe. Cosmos International is where Benjamin's Delicatessen was in the 1950s. (WHHS.)

The apartments at the corner of Farmington Avenue and Quaker Lane were built in the 1920s. In order to build them, the house seen here on the right had to be moved from the corner. The house originally belonged to Benjamin Gilbert, who was one of the most influential leaders of the Quakers. He once owned all the land from West Hill to Trout Brook. (WHHS.)

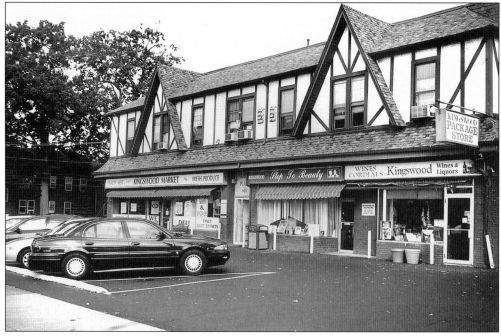

The Kingswood Market has been at 846 Farmington Avenue for as long as anyone can remember. In 1958, Morris Borstein purchased the market. Today it is run by his son David, providing the same great service. (WHHS.)

The Kingswood School moved from the Mark Twain House to West Hartford in 1922. This photograph shows the new campus, with Seaverns Hall on the left and two of the four classroom buildings on the right. In 1969, the school merged with the Oxford School on Prospect Avenue. In 2003, the completion of the Estes Family Middle School realized the joining of the schools to this one campus. (Kingswood Oxford School.)

This building has housed many restaurants over the years. It has been the Manga Reva, the House of Zodiac, and Fiorillo's. In August 1966, it was the Camelot. In 2003, it was the Szechuan Garden. (TOWH.)

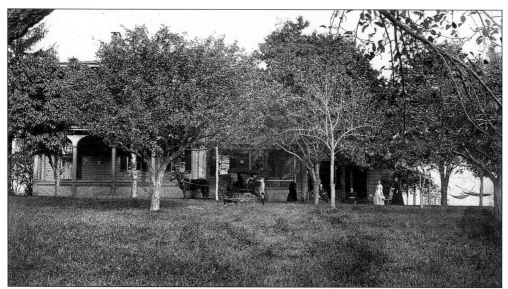

The Glover M. White farm was at 893 Farmington Avenue. The farm originally went from Farmington Avenue to Trout Brook to the Boulevard to Quaker Lane. In 1935, the Junior School started on the property, and in 1946, it began building a series of classroom buildings. In 1967, the farmhouse was razed for the Hampshire House apartments. (WHHS, 0371.)

When the Junior School moved to the Rentschler estate and became Renbrook in 1958, its buildings on Trout Brook were sold to the Children's Museum (now called the Science Center of Connecticut). Cony the whale spouts off in front of the planetarium. To the left is one of the old apple trees from the White orchard. (WHHS.)

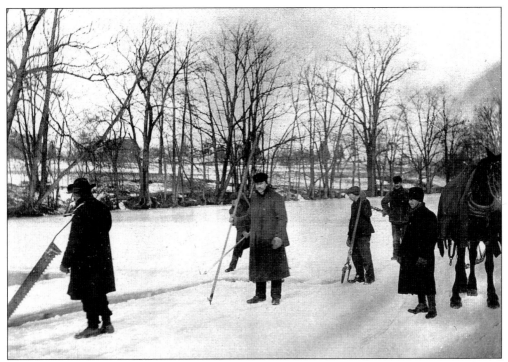

In 1879, Edwin Arnold founded the Trout Brook Ice and Feed Company on the northwest corner of Farmington Avenue and Trout Brook. He dammed the brook at that site to create a large pond. These men are harvesting the ice, which will then be sold to establishments as far away as New York City. Note the man with the saw. (WHHS, 0056I.)

For many years, the Ravelese Farm operated a market at the southwest corner of Trout Brook and Farmington Avenue. It sold vegetables, cider, Christmas trees, and fresh baked goods. In October 1980, the headlines read that the Trout Brook Flood Control Project would not evict the market. When the project was finished, however, the market did not return. (Copyright the Hartford Courant, reprinted with permission; photograph by Arman G. Hatsian.)

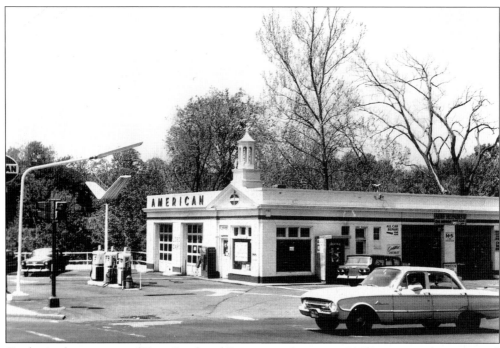

On the northwest corner of Trout Brook and Farmington Avenue, at 914 Farmington Avenue, stood the American gas station. It was razed for the Trout Brook Flood Control Project. (TOWH.)

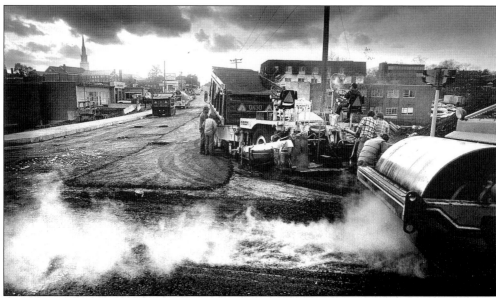

On September 1, 1983, the sidewalk on Farmington Avenue at Trout Brook collapsed during repair. One person was killed and three were injured. For two and a half months, the bridge and road were closed, creating havoc to the businesses in the center. This photograph shows workmen finishing the road repairs for the planned reopening on the next day, Saturday, November 19, 1983. (Copyright the Hartford Courant, reprinted with permission; photograph by John Long.)

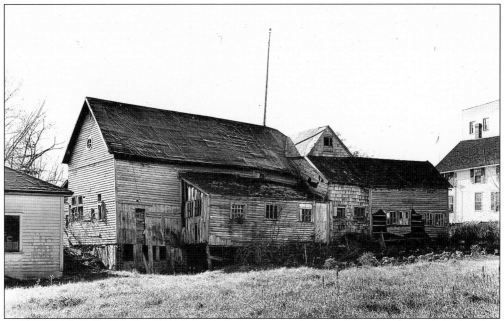

This October 1943 photograph shows the woodworking shop and barns behind 940 Farmington Avenue, the block between Trout Brook and Main Street on the north side. The image clearly documents how West Hartford was primarily an agricultural place. The buildings may have belonged to the Trout Brook Ice and Feed Company. (WHFD.)

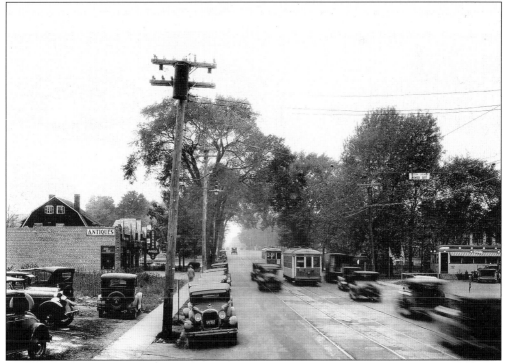

After motorists continued through the center, Farmington Avenue resumed its rural character. This view, looking west, shows Farmington Avenue near Walden Street in 1930. (TOWH.)

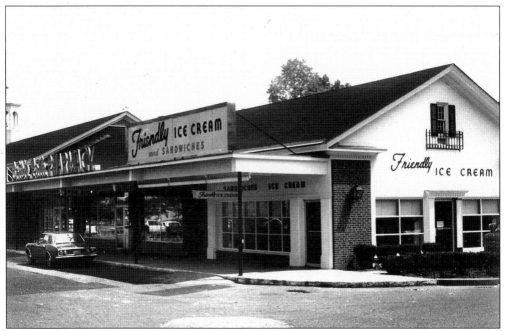

At the intersection of Farmington Avenue and the Boulevard was built the Stop and Shop, with the Bridle Path Pharmacy and a Friendly's. This is how the stores looked on July 17, 1966. Today, Stop and Shop has taken over all of the space. (TOWH.)

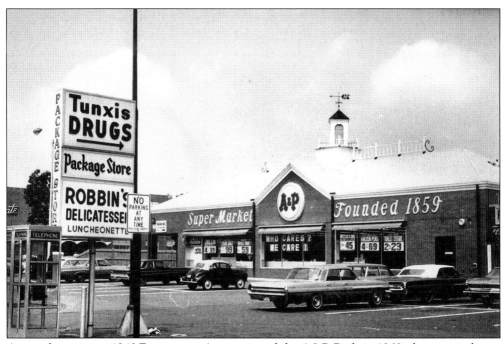

Across the street, at 1240 Farmington Avenue, stood the A&P. Built in 1963, the store is shown here on July 17, 1966. (TOWH.)

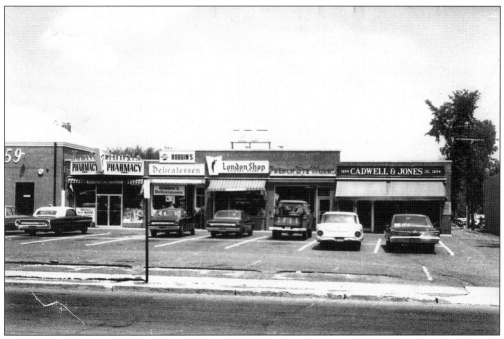

Next to the A&P were the Tunxis Pharmacy, Robbin's Delicatessen, the London Shop (a liquor store), the French Dye Works, and Cadwell & Jones. (WHHS.)

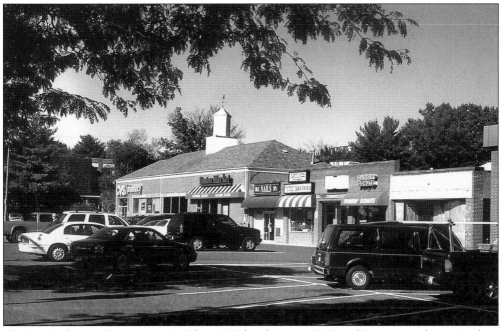

The same plaza is shown in 2003. The A&P has become CVS and Boston Market, joined on the right by Nails, Farmington Avenue Pizza, and Dunkin' Donuts. (WHHS.)

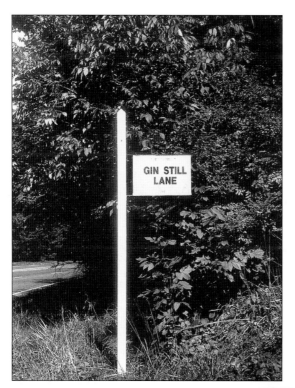

Gin Still Lane, off Farmington Avenue, is named for the place where several commercial distilleries were located in the 18th and 19th centuries. The distilleries manufactured gin and other liquors for local consumption. Still Road, on the Bloomfield border, is also named for the stills that were there. (WHHS.)

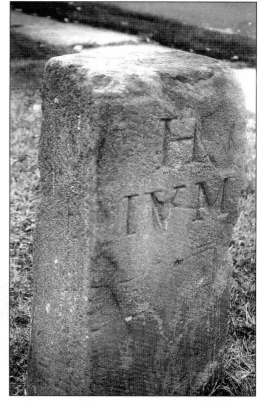

Four Mile Road runs from Farmington Avenue to Sedgwick Road, hardly four miles long. The ancient mile marker at its corner on Farmington Avenue is inscribed, "H IV M," indicating that Hartford is four miles away. Four Mile Road marks the place that was four miles to Hartford, in fact to the Old State House, from which all distances were measured. (WHHS.)

Six

HOMES AND HOMESTEADS

This extraordinary Victorian mansion is the Loomis-Wooley house, which stood on Prospect Avenue just south of Oxford School. It was built in 1874. The Robinson School purchased the house (painted a strong yellow) in 1973 and razed it. Later, the school closed. The loss of this house established the Hartford Architecture Conservancy in greater Hartford. (WHHS, 0180f.)

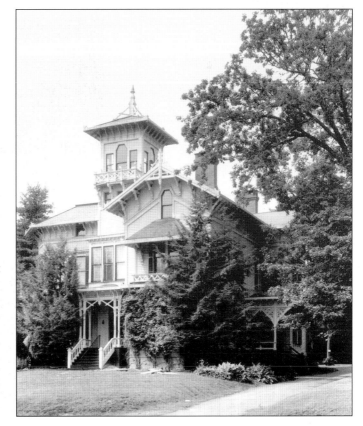

Shown here is an ice truck whose load has shifted, tipping the vehicle. The block of ice can be seen to the right of the truck. Equally important is the background of the photograph. This is the corner of Milton Street and Ardmore Road. Photographs like this preserve the history of West Hartford. (WHPD.)

This house at 202 South Main Street was built in 1725 by Asa Gillet. In 1985, the state decided to identify the oldest house in each town with a plaque. This house was properly nominated, and so declared, but that was challenged by the Sarah W. Hooker House, which had an outhouse that was thought to be older. The plaque on this house was therefore stored in the town vault, where it remains to this day. (WHHS.)

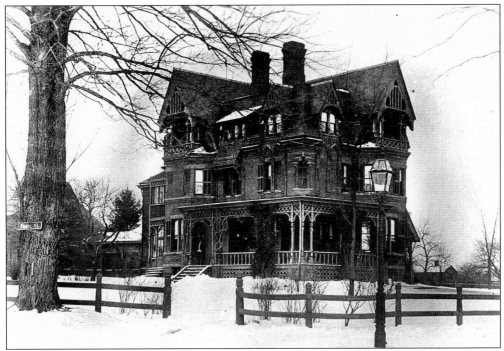

At the northwest corner of Prospect Avenue and Fern Street stood Yung Wing's Victorian mansion. Built in the 1880s, it was later the home of Arthur L. Foster and included a lakelet and deer park. Yung Wing graduated from Yale and later established an educational program where Chinese boys were educated in the Hartford schools. He is buried in Cedar Hill. (WHHS, 0193C.)

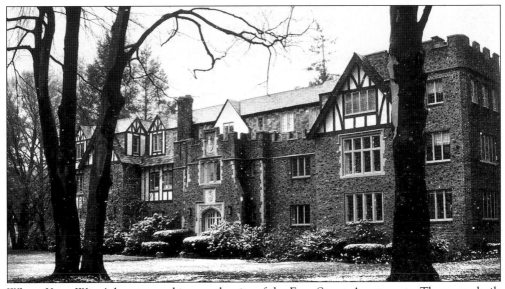

Where Yung Wing's house stood is now the site of the Fern Street Apartments. They were built in the 1930s and, although they primarily face Prospect Avenue, were tagged with the Fern Street moniker. They are now condominiums. (WHHS, 0640P.)

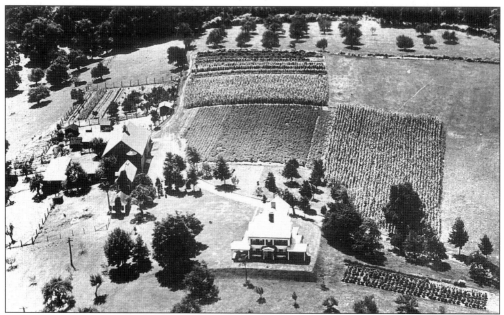

On Avon Mountain stood the Brainard farm. It was the city summer home of Morgan G. Brainard, president of Aetna Life and Casualty. He would go there to escape the summer's heat in Hartford when he was not at Fenwick. The farm also grew vegetables and produced fresh cider and maple syrup for the family. (WHHS, 0245.)

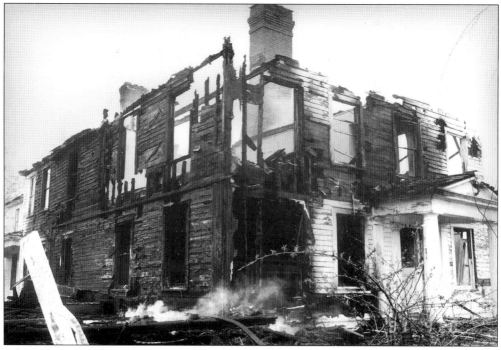

After years of neglect, the barns collapsed and the outbuildings were vandalized. The main house at Brainard farm caught fire on April 20, 1991. In 2003, the site was being developed for private homes called Old Stone Crossing. (WHFD.)

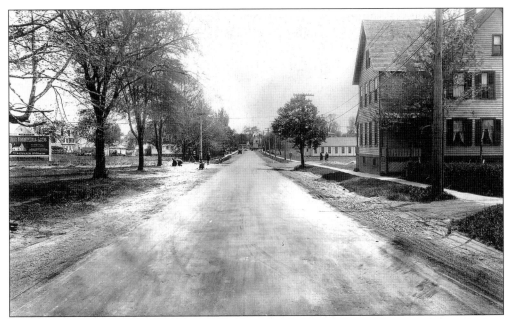

This view, looking south to the Boulevard, shows South Quaker Lane. The picture was taken on May 20, 1926, by John Paulsen. The house on the right is still there. The long white building behind it was the first home of St. Thomas Church. (WHHS, 0219A.)

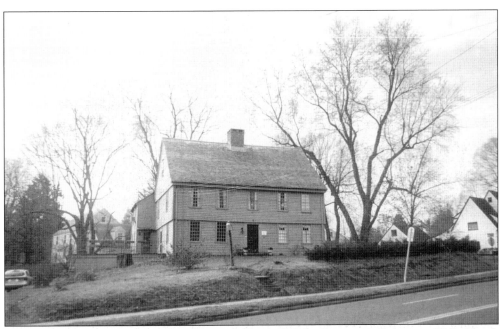

This elegant 18th-century homestead was built in 1769 by Benjamin Colton at 25 Sedgwick Road. It is a sole survivor of the many elegant 18th-century homes that were once located along Sedgwick Road and throughout West Hartford. (WHHS.)

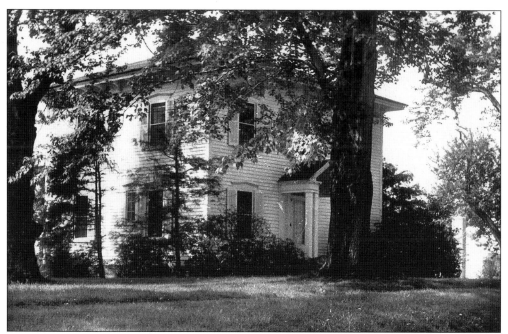

The Col. Solomon S. Flagg house was built on North Main Street near Procter Drive in 1843. His farm was once one of the largest in the town, covering more than 600 acres. He was a major force behind the petition to have West Hartford separated from Hartford and was the first to sign the petition. He became the town's first first selectman. (WHHS, 0197i.)

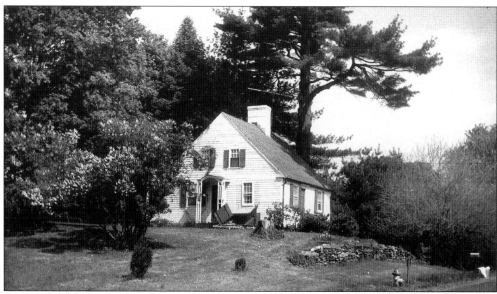

On Mountain Road was the Samuel Farnsworth house. It was built in 1790 and still stands at 537 Mountain Road. (WHHS, 0164.)

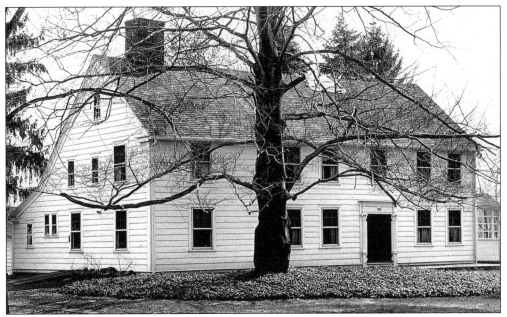

The James Whitman House still stands at 208 North Main Street. James Whitman, a bachelor who inherited the farm and this house, lived there with his two sisters. After his death in 1900, the house was bought by Frederick D. Duffy, who was a schoolteacher and served on the town council. (WHHS, 191.)

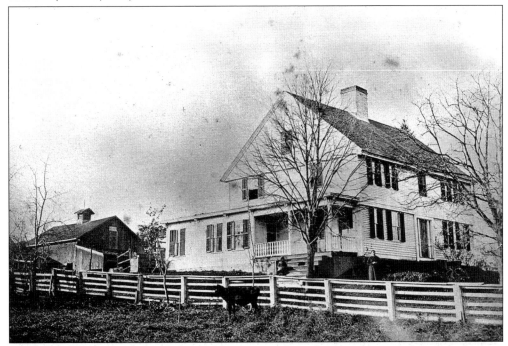

The Hathaway Farm was on the southwest corner of North Main Street and Asylum Avenue. Through the years, parts of the farm were sold for homes. In the 1990s, the last of the barns were demolished, leaving only the main house and a small smokehouse. This picture was taken in 1869. (WHHS, 0173b.)

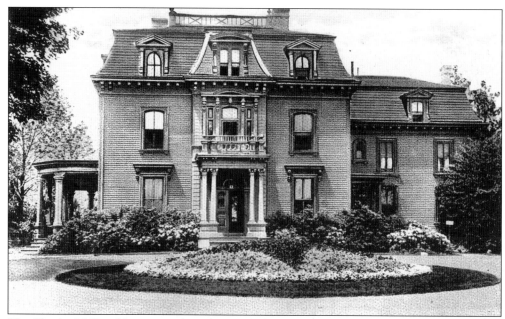

The Charles M. Pond house stood on the west side of Prospect Avenue, overlooking the pond. Charles M. Pond was the son of Gov. Charles H. Pond, who signed the act that separated West Hartford from Hartford. Charles M. Pond willed this mansion, along with the estate, to the city of Hartford to create a park named for his wife. Elizabeth Park is 101 acres. (WHHS, 0182A.)

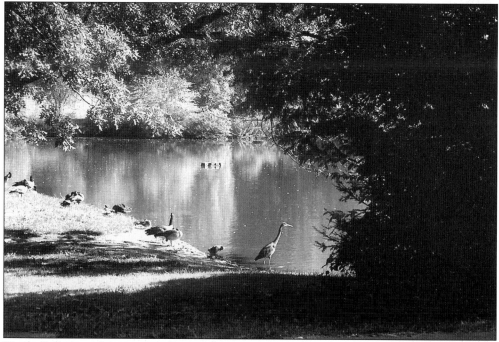

Elizabeth Park, with its rose garden, in the center of Charles M. Pond's racetrack, is also home to wildlife. On a summer morning, ducks can be seen beside the pond, as well as a young great blue heron, seen here on the right. (WHHS.)

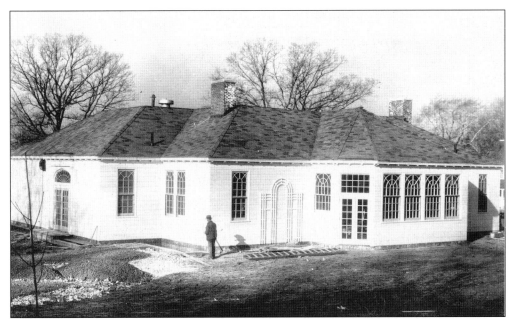

T. Belknap Beach, grandson of the founder of the Travelers, donated to the town the spacious lot on the northeast corner of Asylum and Steele Road for a school. This is the east side of the Beach Park Kindergarten and Primary School. It opened in 1926. The school was closed in 1973. In 1999, it was sold to St. Joseph College and is today the college's school for young children. (WHHS, 0395d.)

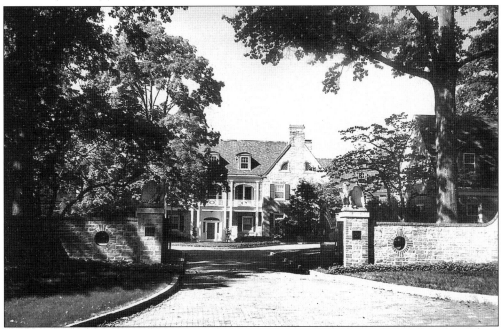

In the late 1920s, Francis B. Cooley sold his estate at 151 Farmington Avenue to Aetna and bought the Huntington estate at 1093 Prospect Avenue. He razed the house and in its place built this modern house, which was affectionally called Castle Cooley. It was later the home of E. Clayton Gengras. (WHHS.)

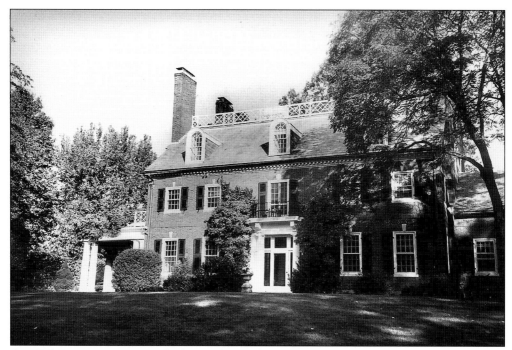

At 1075 Prospect Avenue is the house designed by Charles Platt for Robert H. Schutz Sr. and his son Robert H. Schutz Jr. The son was a prime mover in the restoration of the Mark Twain House, and his grandfather had been the Clemens' family doctor. (WHHS.)

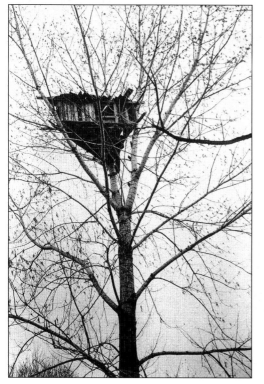

The location of this boys' tree house is not known, but one must marvel at the ingenuity that must have accompanied its construction. How were the materials lugged to that height, and how did the occupants reach the lofty perch? Clearly OSHA did not know of its construction. (WHHS, 0196D.)

Seven

ALL AROUND THE TOWN

In 1953, at the Wadsworth Atheneum's Avery Theater, Gilbert and Sullivan's *Iolanthe* starred fifth-grader Kathy Grant, known today as the actress Katharine Houghton. Opposite her as Strephon was classmate Baker Salsbury. Houghton later appeared with her aunt Katharine Hepburn in *Guess Who's Coming to Dinner*. Salsbury is now the director of health and social services for East Hartford. And yes, Katharine Hepburn did attend the performance. (Renbrook School.)

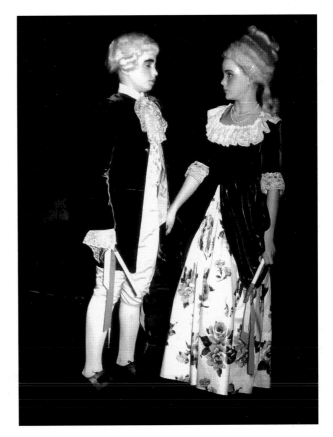

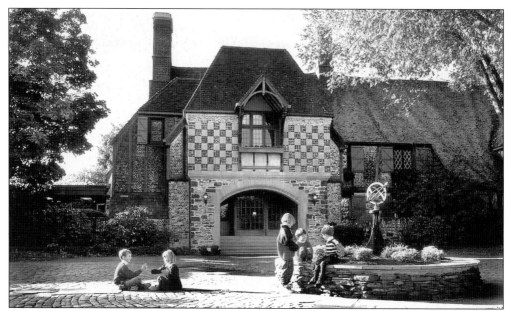

In 1957, the Rentschler estate on Avon Mountain was offered to a nonprofit group at $1 a year. Florence Greene, the head of the Junior School, recognized it as the opportunity for the school. With Ted Stedman, the school's chair, Greene went to New York and presented the case. The executor in New York listened to Greene's wise words and gave the estate to the school. The school changed its name to Renbrook and is now a school for children in kindergarten through ninth grade. (Renbrook School.)

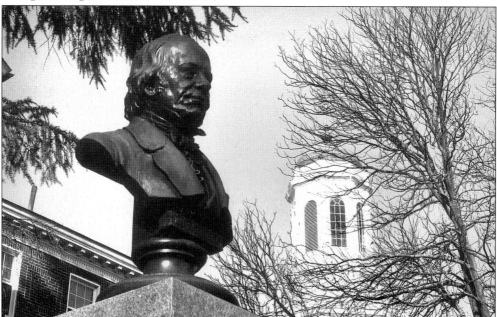

The American School for the Deaf was founded in Hartford in 1816. One of its first teachers was Laurent Clerc (depicted in this bust), the distinguished teacher of the deaf from France. Behind the bust is the cupola of the school's main building in West Hartford, where the school moved to in 1921. (WHHS.)

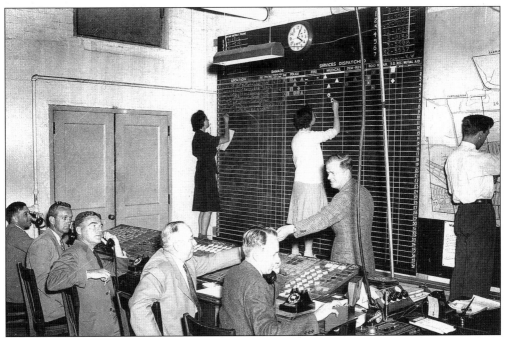

In the 1950s, civil preparedness was on everyone's mind. Shown here is a rehearsal in case there was a nuclear attack or similar emergency that would affect the town. (TOWH.)

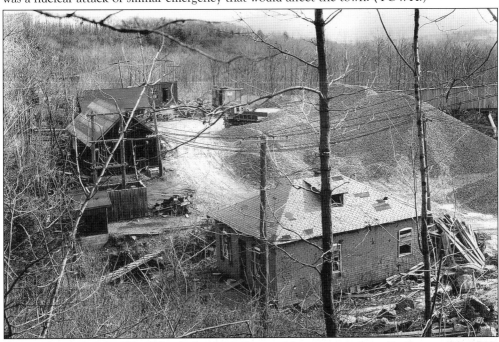

This is the site of the West Hartford police's first murder investigation. On January 29, 1932, Joseph Kaplinos, the night watchman and laborer at the Avon Mountain quarry, was found murdered, his head smashed in and his body partially burned. Quick work identified the murderer as Bolish Maskaitis, who on April 7, 1932, was sentenced to life in prison. The shack where the murder took place is in the foreground. (WHPD.)

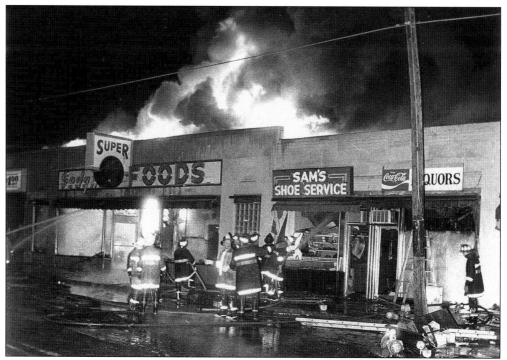

On February 20, 1979, Sedgwick Super Foods, on the corner of South Main Street and Sedgwick Road, caught fire. No cause was discovered, and the stores were totally destroyed. The plaza was later rebuilt. (WHFD.)

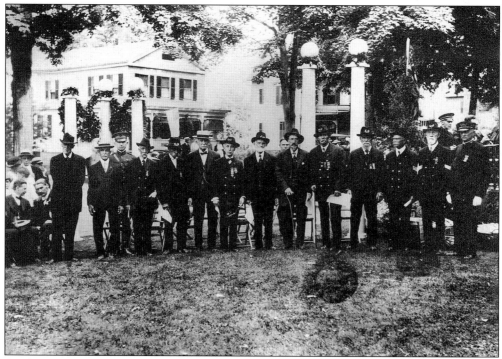

Civil War veterans gather on Memorial Day in West Hartford Center. (WHHS, 0118F.)

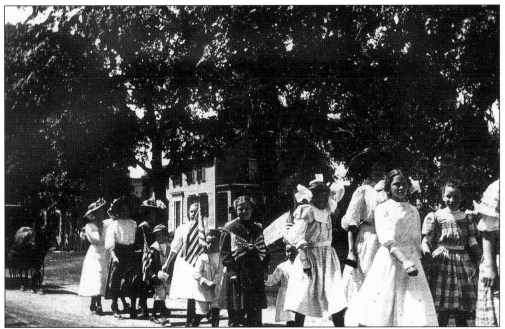

The Memorial Day parade in 1915 featured schoolchildren marching along Main Street. (WHHS, 0006c.)

On February 27, 1932, West Hartford celebrated George Washington's 200th birthday with a reenactment and a tree dedication. Shown here are some of the participants. The gentleman in the center is William H. Hall, a school dropout who grew up to be a teacher, principal, and superintendent of the West Hartford schools. (WHHS, 0112F.)

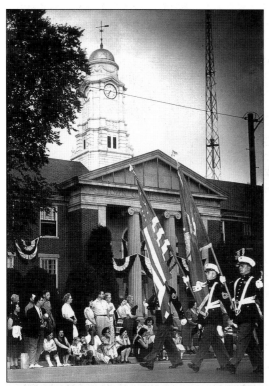

On June 12, 1954, West Hartford formally celebrated the 100th anniversary of its separation from Hartford. Here, the Marine color guard leads the parade in front of the town hall. (Copyright the Hartford Courant, reprinted with permission; photograph by Harry Batz.)

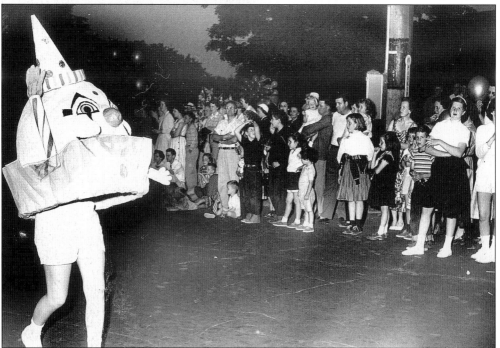

At the West Hartford centennial parade, youngsters enjoy the sight of a group of young ladies dressed as pieces of candy advertising the Hilliard candy store. (Copyright the Hartford Courant, reprinted with permission.)

Getting a big hand at the centennial parade were these youngsters who had previously won the fancy turnout award at the Children's Horse Show. From left to right are Billy Cotter, of Farmington; Tommy Hayes, of Unionville; and Diane Mulcunry, of Ferncliff. (Copyright the Hartford Courant, reprinted with permission.)

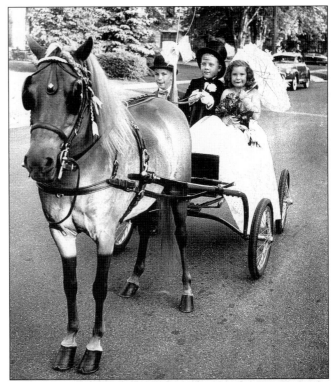

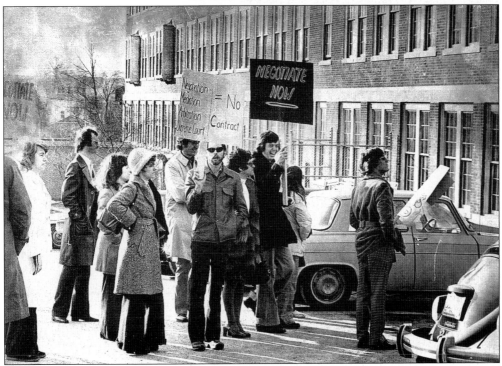

On February 21, 1974, West Hartford teachers held a protest march against the board of education. At issue were the teachers' contracts. (WHHS, 0641A.)

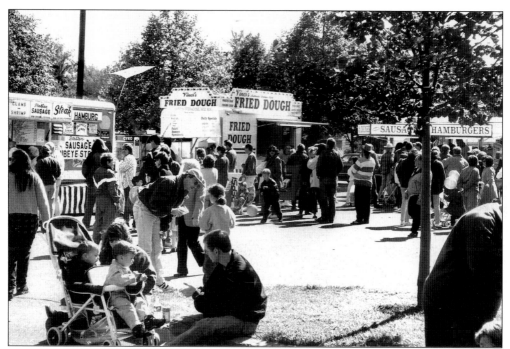

In 1987, town clerk Nan Glass had the idea of holding an old-fashioned townwide celebration. "Celebrate! West Hartford" has become an annual event held around the town hall. In the parking lot, vendors provide sausages, fried dough, and other festive treats. (WHHS, 02745.)

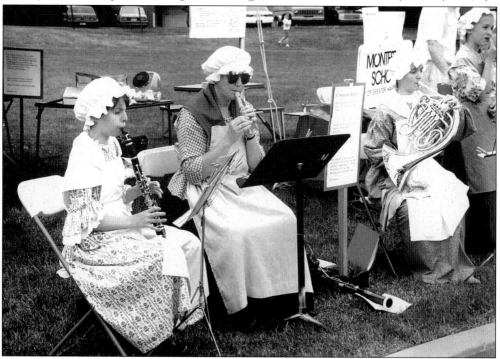

The annual celebration brings out local talents to entertain and amuse the crowds. Note the sunglasses on the woman in the center. (WHHS, 0286.)

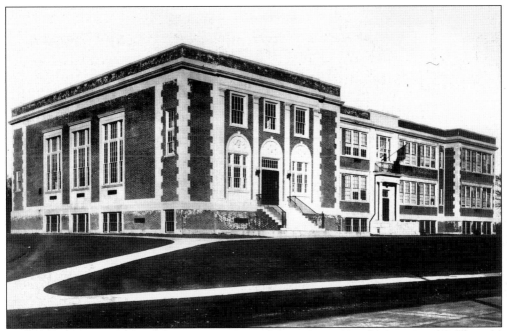

The Talcott Junior High School was named for James Talcott, Elmwood native and successful New York businessman. The land on which it stands was donated by the Talcott estate. The school closed in 1979. It was sold to Coleco for its headquarters and later that of Ames department store. The building now sits empty. (WHHS, 0101C.)

Students at the Talcott Junior High School held an ice-cream sale. It is not clear if these are happy customers or the workers enjoying the product they were to sell. (WHHS, 0101B.)

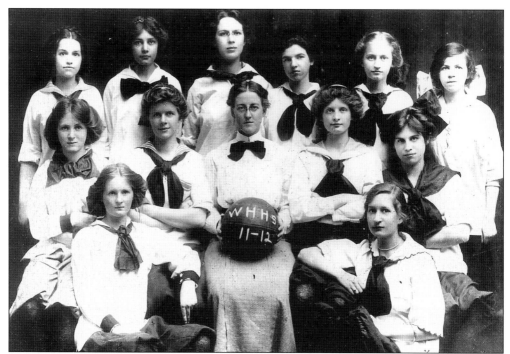

The Hall High School women's basketball team of 1911–1912 poses with coach Louise Day Duffy, for whom Duffy School was named in 1954. (WHHS, 0011A.)

The Hall High School drill team is going through the paces. From 1924 to 1957, there was only one high school in West Hartford, Hall High School (now the town hall, in West Hartford Center). In 1957, Conard High School was built in the southern part of the town. In 1970, the new Hall High School was built in the northern part. (WHHS, 0310.)

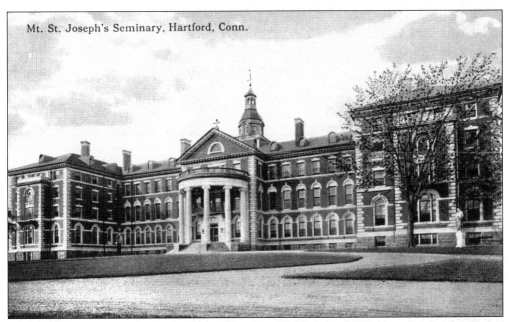

Mt. St. Joseph's Seminary, Hartford, Conn.

Mount St. Joseph Academy moved to Hamilton Heights in 1909. Founded by the Sisters of Mercy, it closed in 1978. The buildings then served as a training center for the Hartford Insurance Group. In 1998, it became an assisted living facility. (Richard Mahoney.)

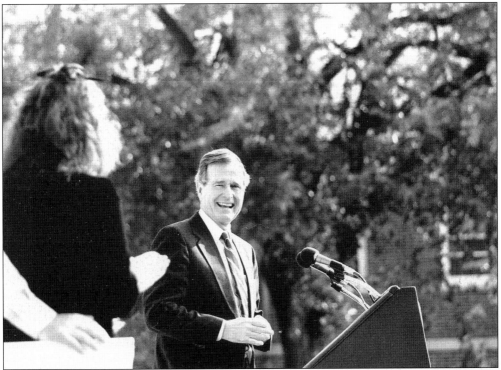

The Sisters of Mercy also founded St. Joseph College in 1932. In 1988, Paton Ryan, president of the college, invited the presidential candidates to speak. On September 30, 1988, Vice Pres. George H.W. Bush came to St. Joseph College for a campaign rally. (WHPD.)

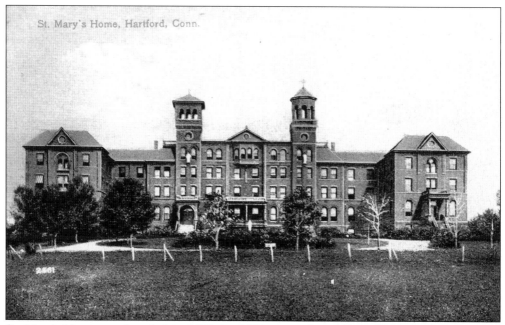

St. Mary's Home, Hartford, Conn.

St. Mary's Home was founded in 1880. In 1896, it purchased Rose Terry Cooke's farm, on the corner of Albany Avenue and Steele Road, and constructed this building at 2021 Albany Avenue in 1896. The surrounding neighborhood consisted of farms, with dairy cattle grazing on the property. (Richard Mahoney.)

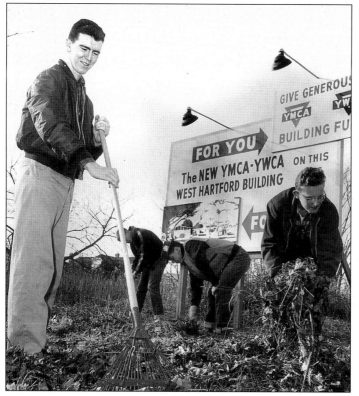

Shown from left to right, Walter Keefe, Bill Slights, Pete Steinle, and Jack D'Huart help clean the parcel at 21 North Main Street that was to become the home of the new YMCA and YWCA. The building was for sale in 2003. (WHHS, 0205.)

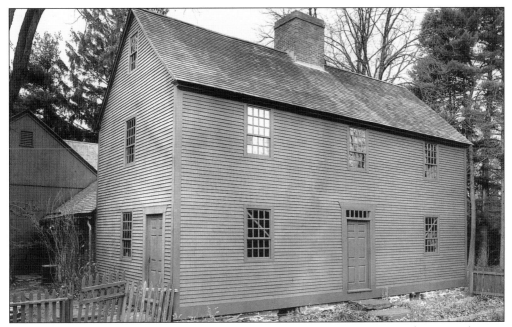

Noah Webster was born in this house at 227 South Main Street in 1758. At that time, this was an 80-acre farm. Webster graduated from Yale in 1778 and taught in Glastonbury and West Hartford. In 1783, he published *The Webster Spelling Book*, followed by the dictionary in 1828. The house is now a museum open to the public. (WHHS, 0648.)

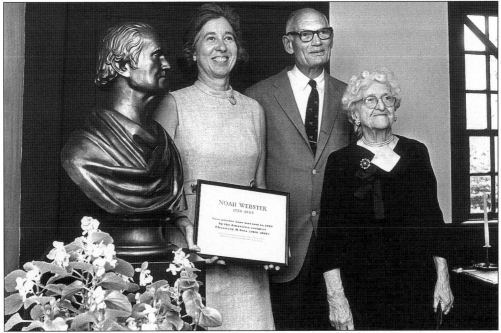

On May 28, 1971, Noah Webster's great-granddaughter Lylean Fowler Field (left) came to the Noah Webster House. With her are Gordon Bennett and Claire Knowlton, the president of the board. In 1962, Bennett approached Fred Hamilton, whose family owned the house, and was able to persuade them to donate Webster's home so it would be shared. (WHHS.)

One of the more striking buildings in West Hartford is St. Peter Claver Roman Catholic Church, off Farmington Avenue at 47 Pleasant Street. On May 1, 1970, Archbishop John F. Whealon consecrated the church. (WHHS.)

The Rockledge farm was the 120-acre property west of South Main Street. As the Sherman farm, it was known for its purebred cattle. In 1924, Wilton W. "Mike" Sherman converted part of his farm into a nine-hole golf course. In 1927, he added another nine. After Sherman's death in 1959, the town purchased the land for the Rockledge Country Club. (WHHS, 0051E.)

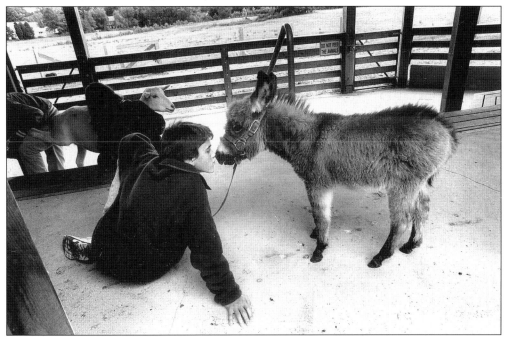

Westmoor Park, a 56-acre farm off Flagg Road, was given to the town in 1974 by Charles and Leila Clark Hunter. The park runs a number of programs for schoolchildren. In 1992, the 4-H Club was headquartered at the park. Shown here is Jake Berkowitz, age 13, rubbing noses with the new donkey at Westmoor Park. (Copyright the Hartford Courant, reprinted with permission; photograph by Sherry Peters.)

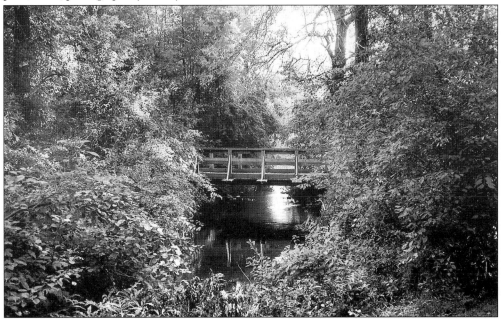

Part of the property at Westmoor Park included a stream with a bridge. Early in the morning or at dusk, you can see deer, turkeys, great blue heron, and other wildlife, just minutes from the traffic snarls of Bishops Corner. (WHHS.)

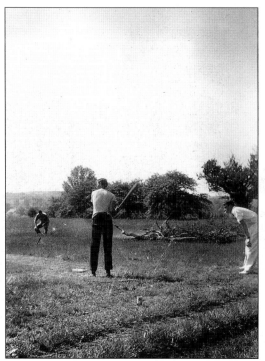

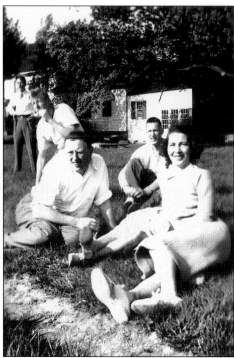

In the late 1930s, Westmoor Park was owned by the bank. The main house was rented to Chas and Edie Salsbury, and the chauffeur's cottage was rented to Jack and Helen Faude. On Saturdays in the summer, the flat polo field would be mowed for community baseball games. On the right, Dick and Betty Butler watch the game. Art Gregory is in the background. (Private collection.)

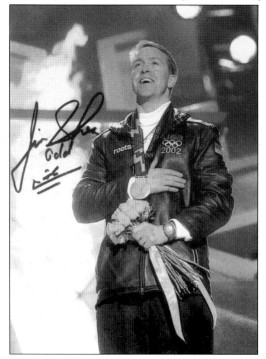

Jim Shea grew up on Sunset Farm in West Hartford, where his parents and his maternal grandparents, Edgar and Sally Butler, lived. On February 20, 2002, he won the gold medal in the men's skeleton competition at the Winter Olympics at Salt Lake City. Taken at the awards ceremony, this photograph shows Shea proudly placing his hand on his heart during the playing of the national anthem. (Shea family collection; photograph by Tea Karvinen.)

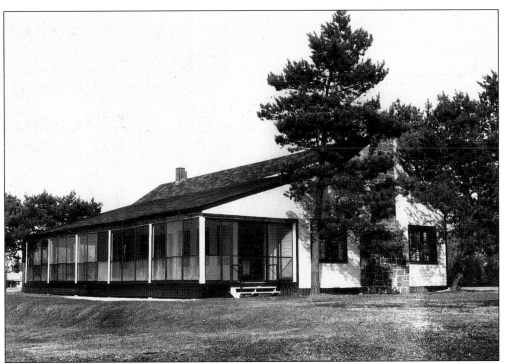

The Buena Vista Golf Club was set up by the town in 1943. It consists of 70 acres. This photograph shows the clubhouse, off Buena Vista Road. (WHHS, 0249.)

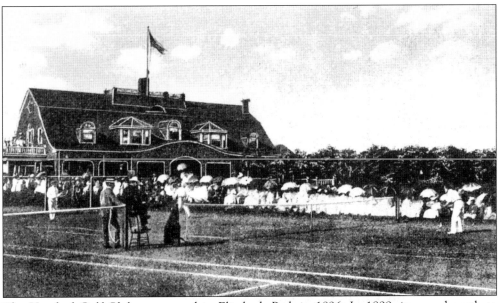

The Hartford Golf Club was started in Elizabeth Park in 1896. In 1899, it moved north to the Huntington Farm and some 99 acres off Belknap Road. This is why the street by the park connecting Asylum Avenue to the club is called Golf Road. Pictured here is the first clubhouse, which was later replaced by a larger one. In the 1950s, the club moved north of Albany and the original course was sold to housing developers. (Richard Mahoney.)

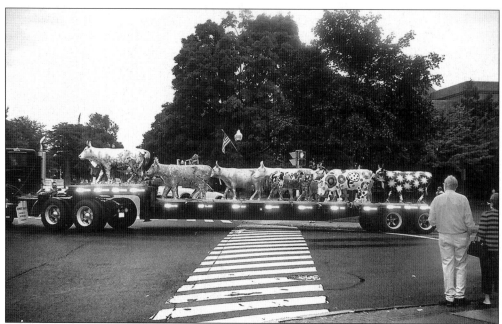

Several years ago, West Hartford's Jerry Elbaum saw a herd of painted cows in Switzerland. Something clicked and he bought the idea and founded the Cow Parade. For the past five years, over $5 million has been raised for charities across America and in Japan and the United Kingdom. On September 3, 2003, the cows came home, literally, to West Hartford Center. (WHHS.)

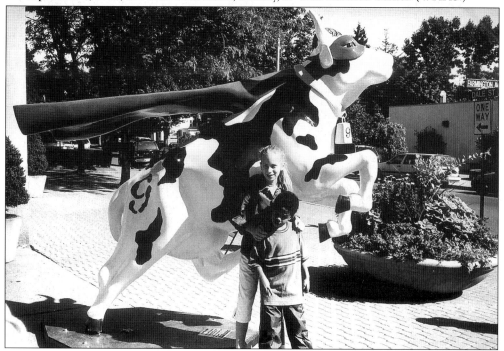

Super Cow was sponsored by Guida's Milk and Ice Cream and by Walker Crane and Rigging. The sculpture was created by Scott Tao LaBossiere. The Cow Parade in the center attracted thousands of visitors. (WHHS.)

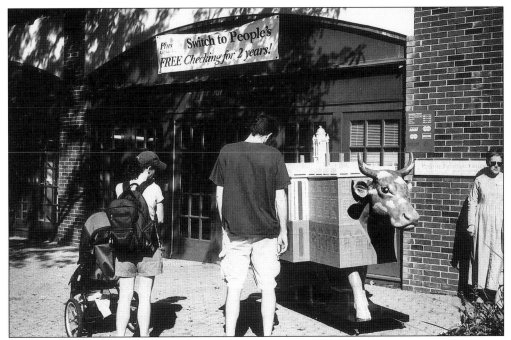

Gigi Horr Liverant and Peter Arkell teamed up to create the Old State Cow-se for People's Bank. The some 60 cows were on the sidewalks, in the windows, on Goodman Green, and by the town hall, creating a free art stroll. (WHHS.)

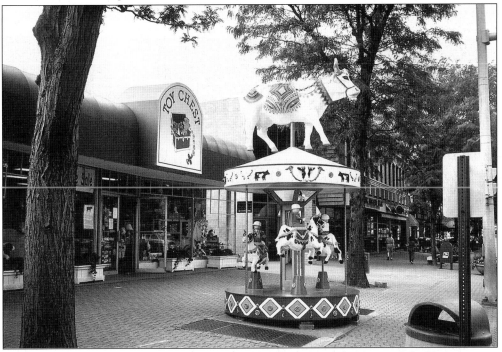

In front of the Toy Chest on Farmington Avenue, Lego created the Cow-a-Sel of Imagination. In addition to the cows, there were tee shirts and hats and a book on the cows. On February 7, 2004, all the cows were auctioned off for charities. (WHHS.)

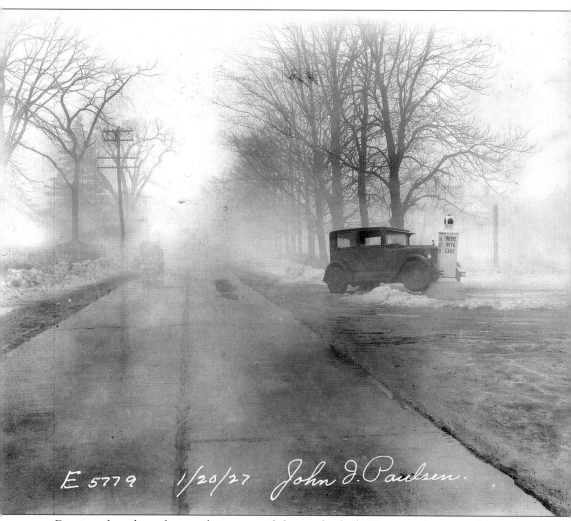

E 5779 1/20/27 John J. Paulsen.

Despite what the pylon in the center of the road asked, "Drive with care," this owner on January 20, 1927, probably wished he had paid attention. It is important that we share and preserve the stories of the past so the stories can continue. If you have pictures or know of pictures, please contact Wilson H. Faude, care of the West Hartford Historical Society, Noah Webster House, 227 South Main Street, West Hartford, CT 06107-3430. (WHPD.)